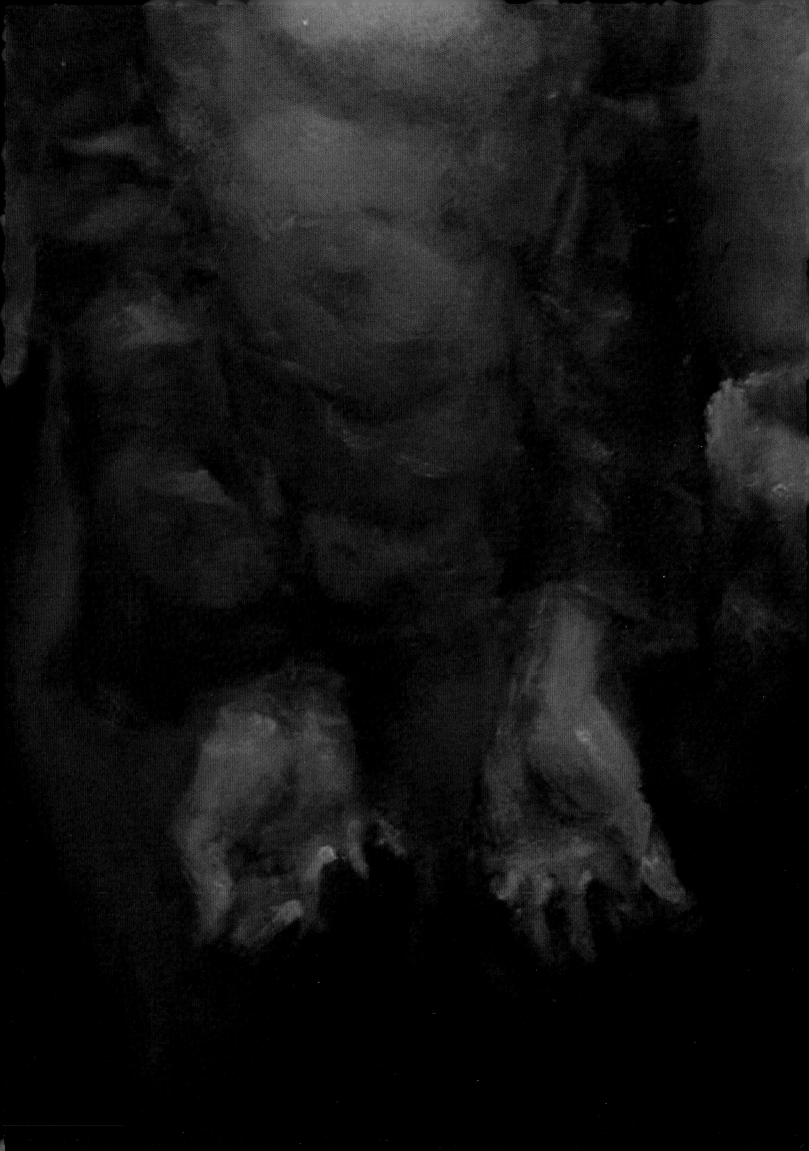

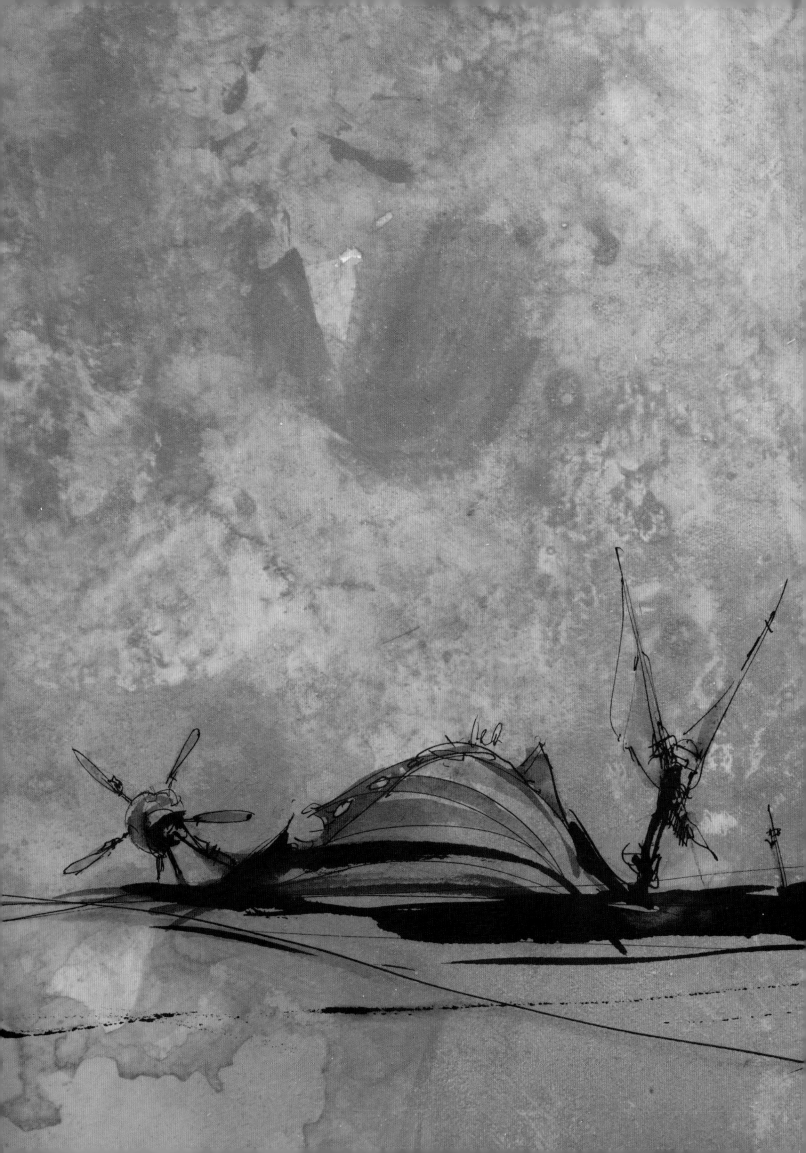

Counterweight

the Art and Concepts of Rick O'Brien

designstudio PRESS

dedication

To my love, Mindy

contact info

Rick O'Brien can be reached by e-mail at: **rickobrien.tmp@earthlink.net**
To see more of Rick's work, visit: **www.themonumentproject.com**

COUNTERWEIGHT
the art and concepts of Rick O'Brien

Published by
Design Studio Press
8577 Higuera Street
Culver City, CA 90232

Website: www.designstudiopress.com
E-mail: info@designstudiopress.com

Printed in China: First edition, April 2008

10 9 8 7 6 5 4 3 2 1

ISBN-10: 1-933492-26-0
ISBN-13: 978-1-933492-33-9

Library of Congress Control Number
2007943821

Graphic Design: Rick O'Brien and Scott Robertson
Photography by Roxanne Morelli

contents

introduction 006

1 the paragon of animals 009

2 perspective through geography 025

3 the range of humanity 039

4 peripheral 071

5 relics 111

closing thoughts 122

about the artist 124

index 126

introduction

Captive in the upper levels of Taipei 101 stirs a giant orb: cradled, tethered and confined. Visible only from within its glass and steel host, the leviathan remains on constant watch, scrutinizing the unpredictable forces of nature. Compensation is physics at a very basic level and hardly a spellbinding concept. The impact of this action, however, is profound in its simplicity. It is the knowledge and understanding that behind every movement, decision, idea, and aesthetic, there are forces at work constantly shaping, adjusting and defining them. It is acknowledging that truth lies beyond the surface, and a reminder that has helped clarify in my own mind a philosophy that continues to dominate my work.

Counterweight is an introduction to a work in-progress, and a forum for exploring issues and aesthetics common to Man.

_RDO'B

Counterweight - Rick O'Brien

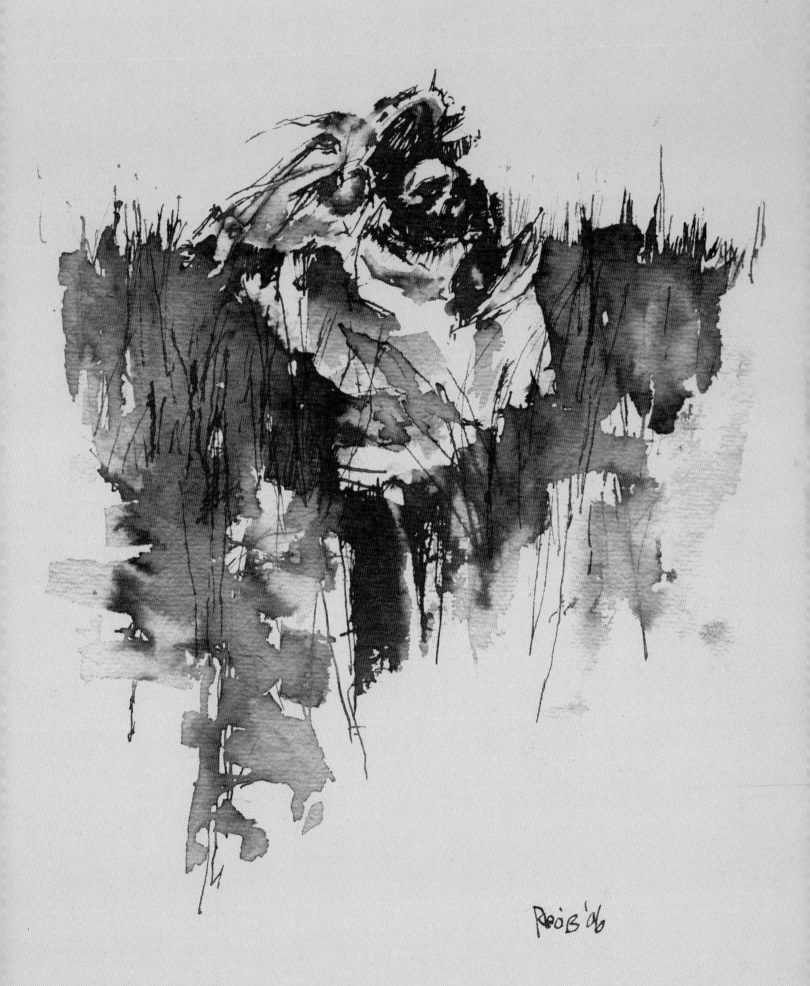

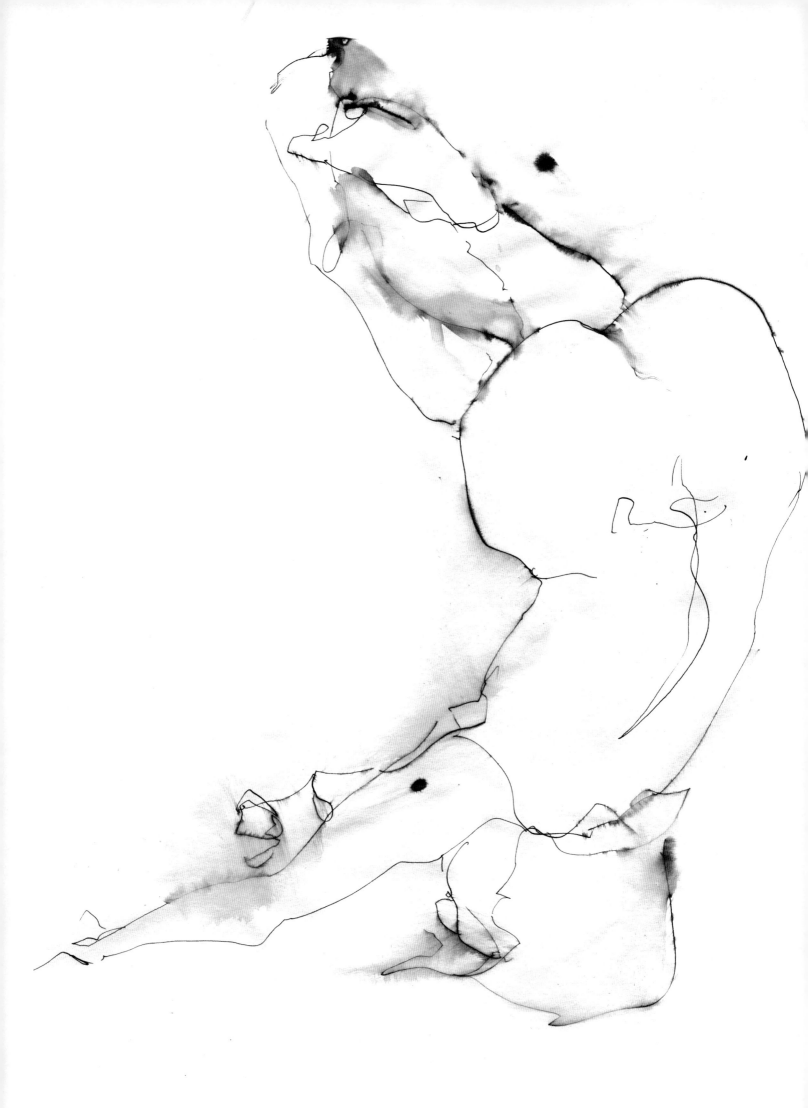

the paragon of animals 1

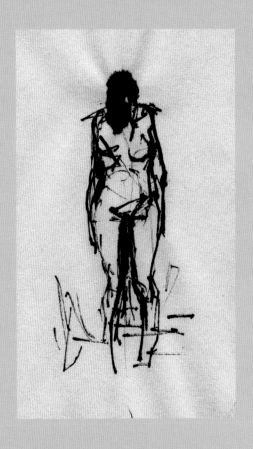

"What a piece of work is a man! How noble in reason, how infinite in faculties, in form and moving how express and admirable, in action how like an angel, in apprehension how like a god–the beauty of the world…"

Shakespeare

What Hamlet may have dismissed facetiously, I hold in earnest.

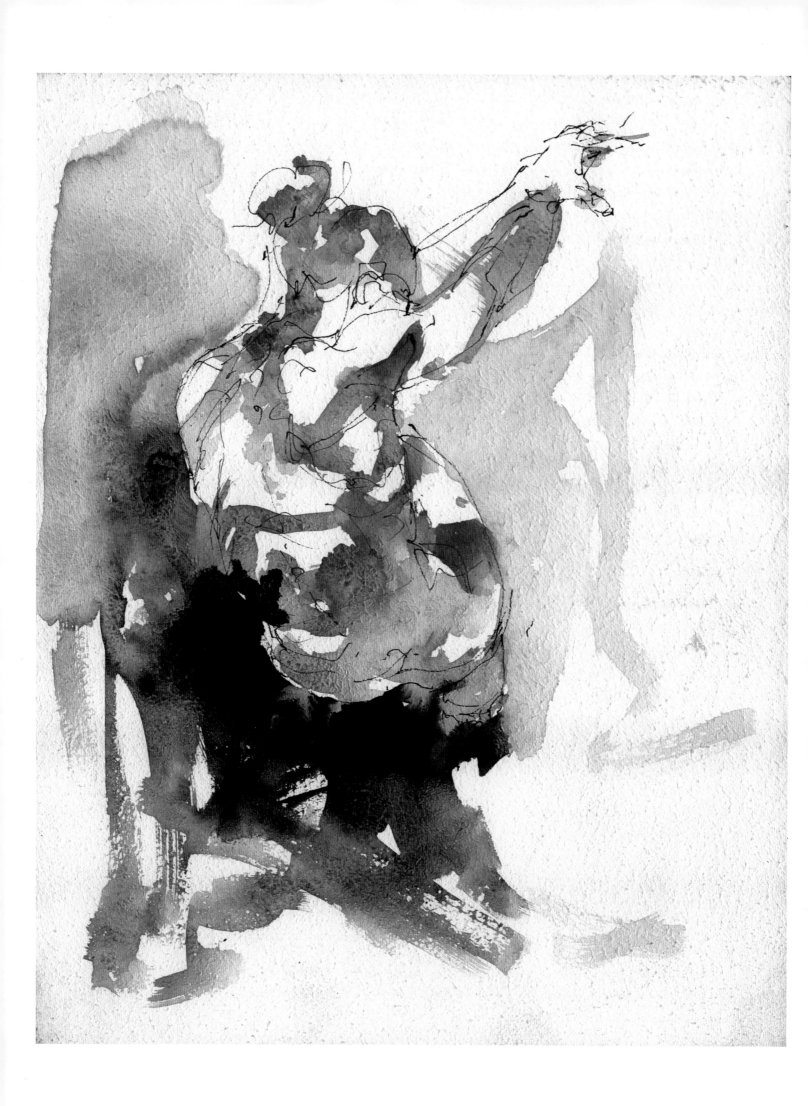

010 Counterweight - Rick O'Brien

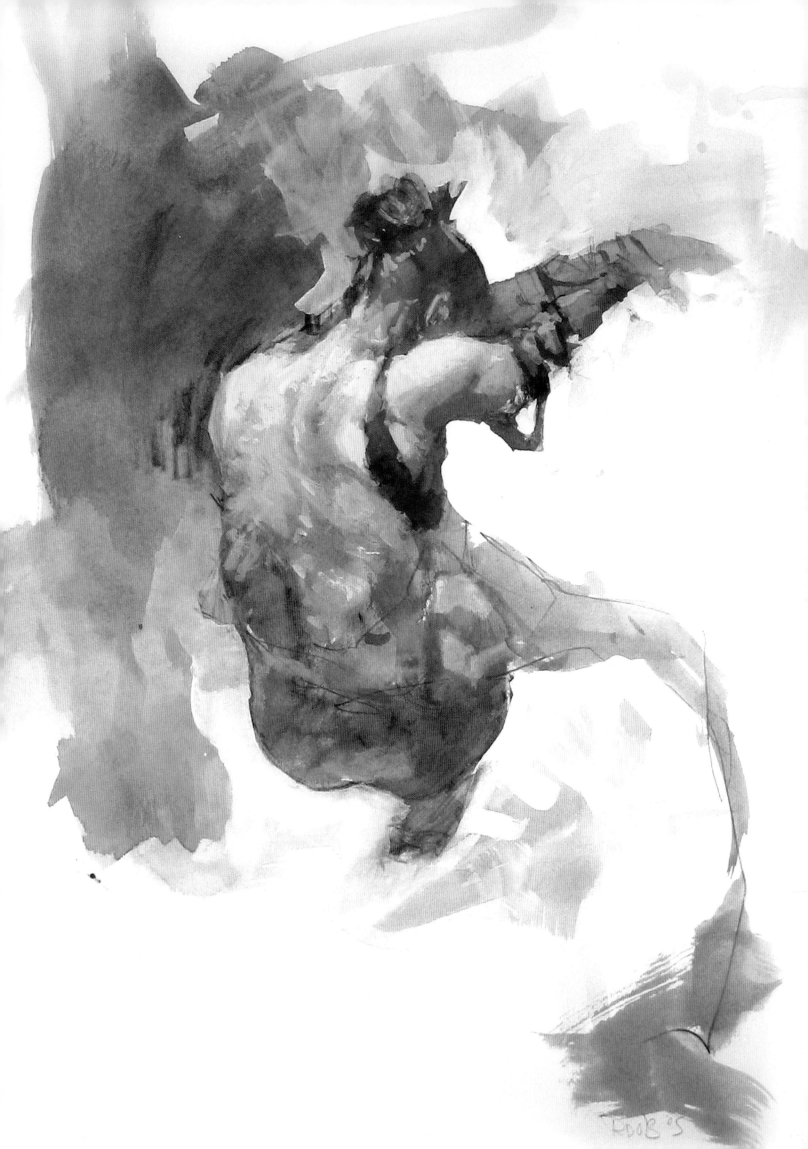

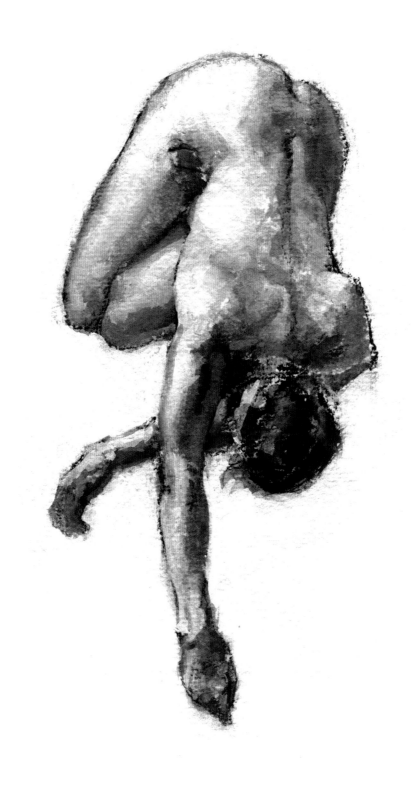

012 COUNTERWEIGHT - Rick O'Brien

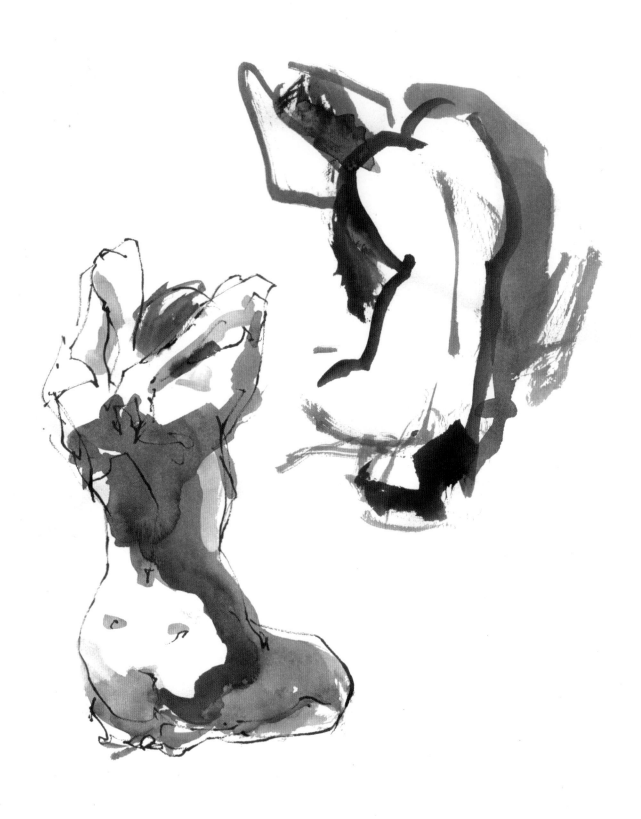

CounterWeight - Rick O'Brien

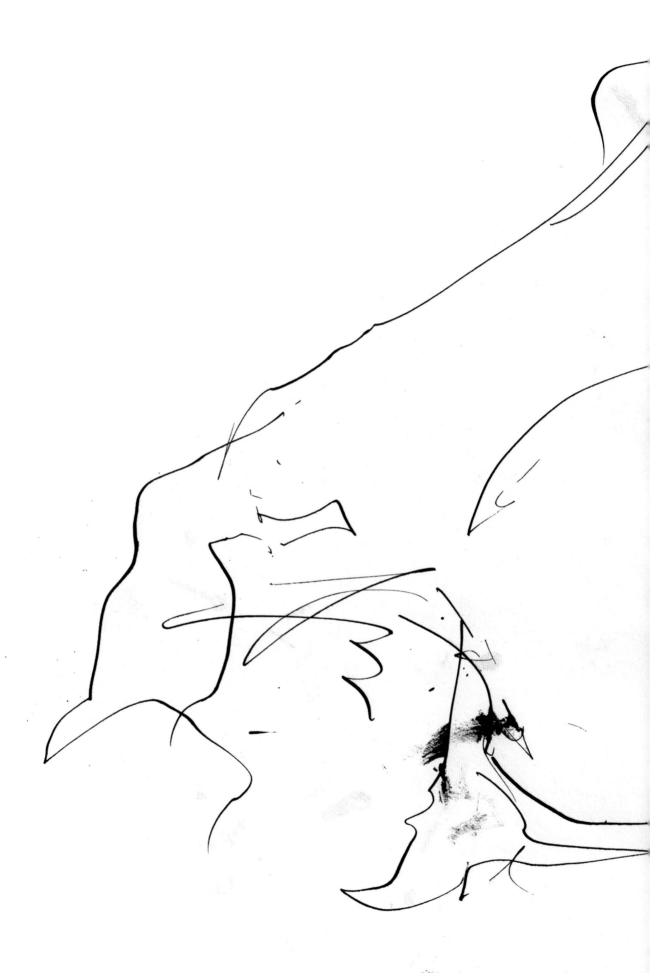

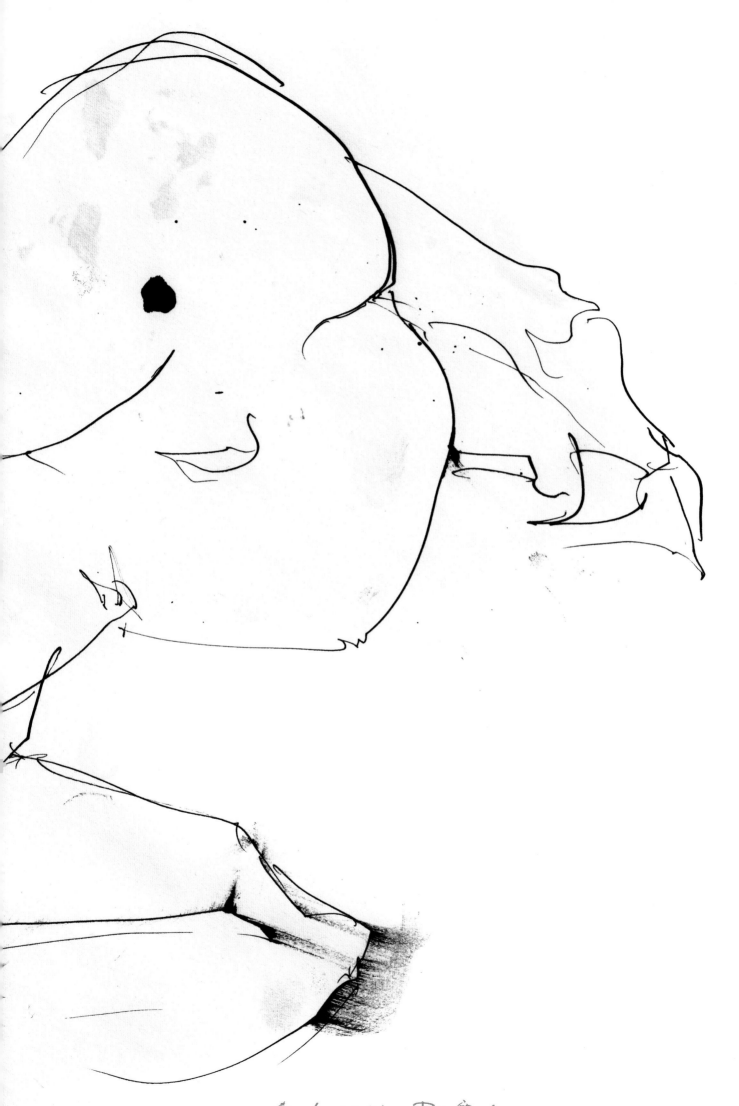

Counterweight - Rick O'Brien

015

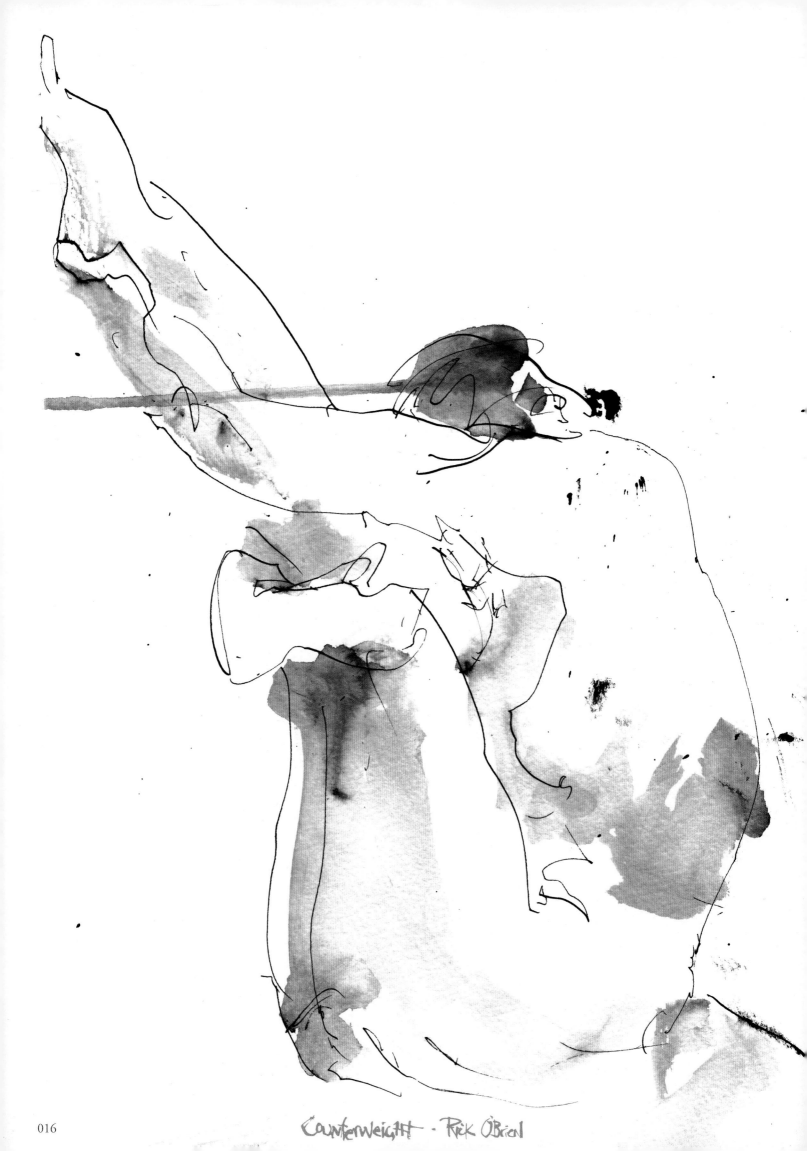

Counterweight - Rick O'Brien

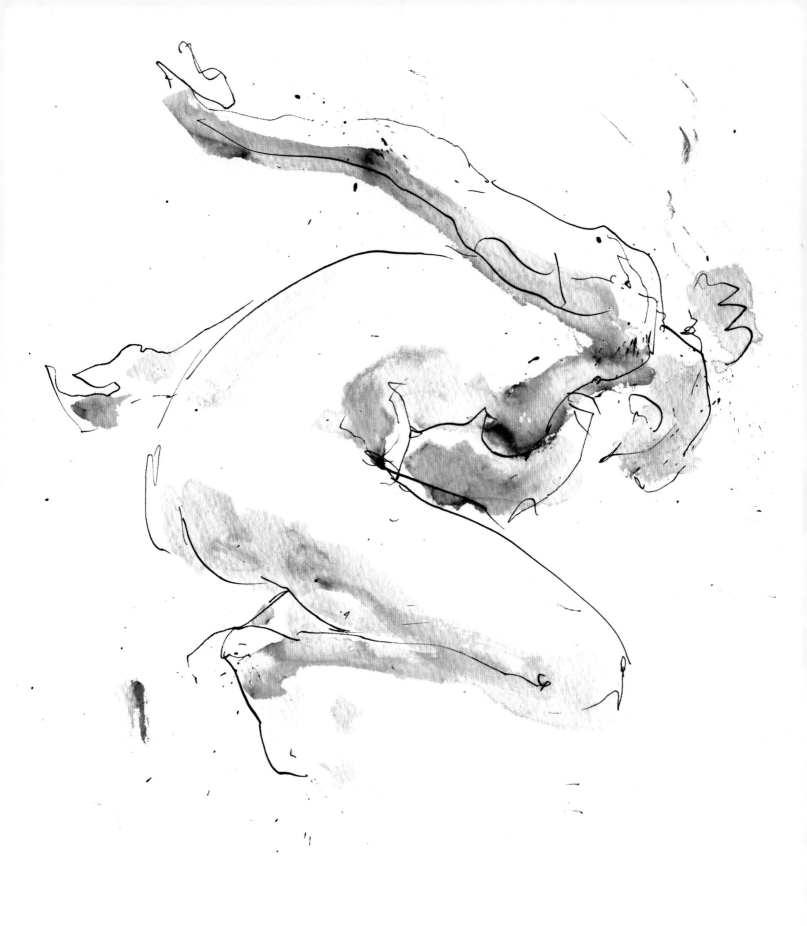

Counterweight - Rick O'Brien

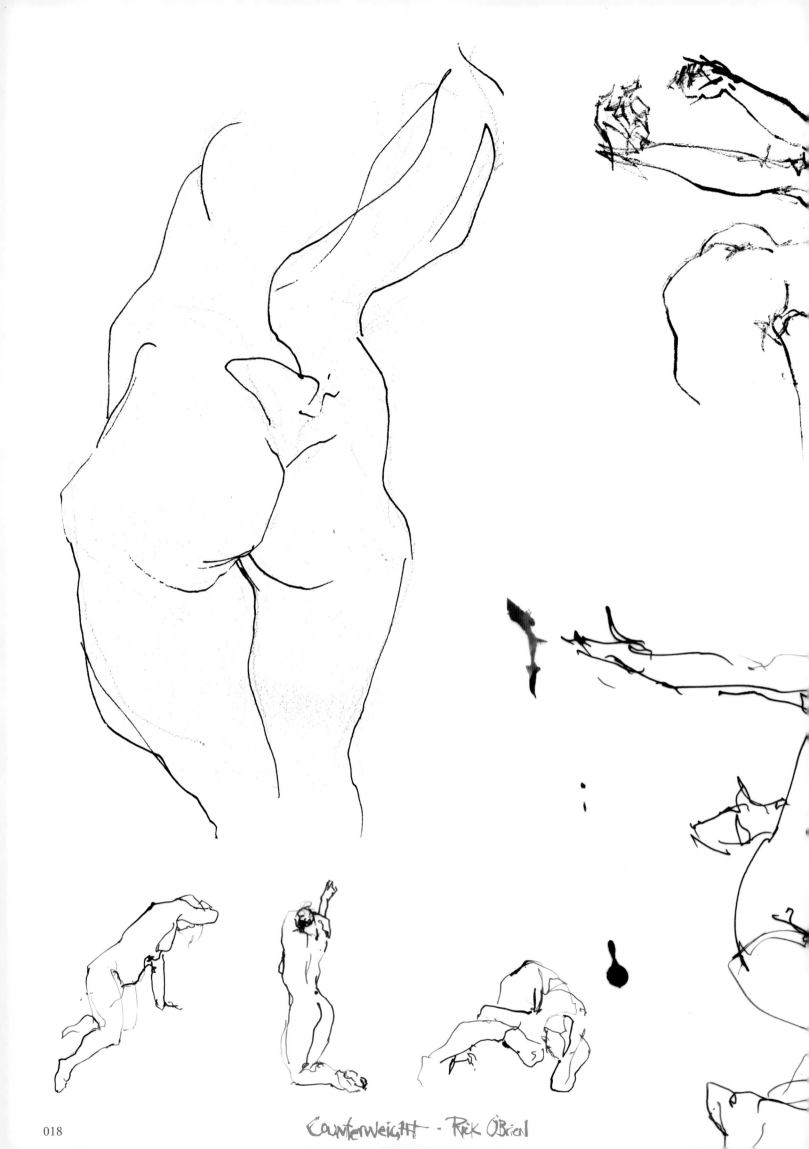

Counterweight - Rick O'Brien

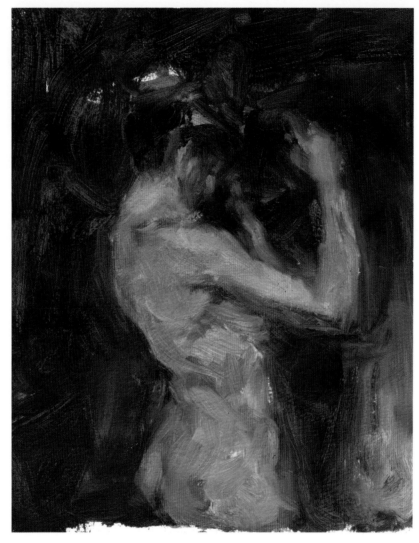

Counterweight - Rick O'Brien

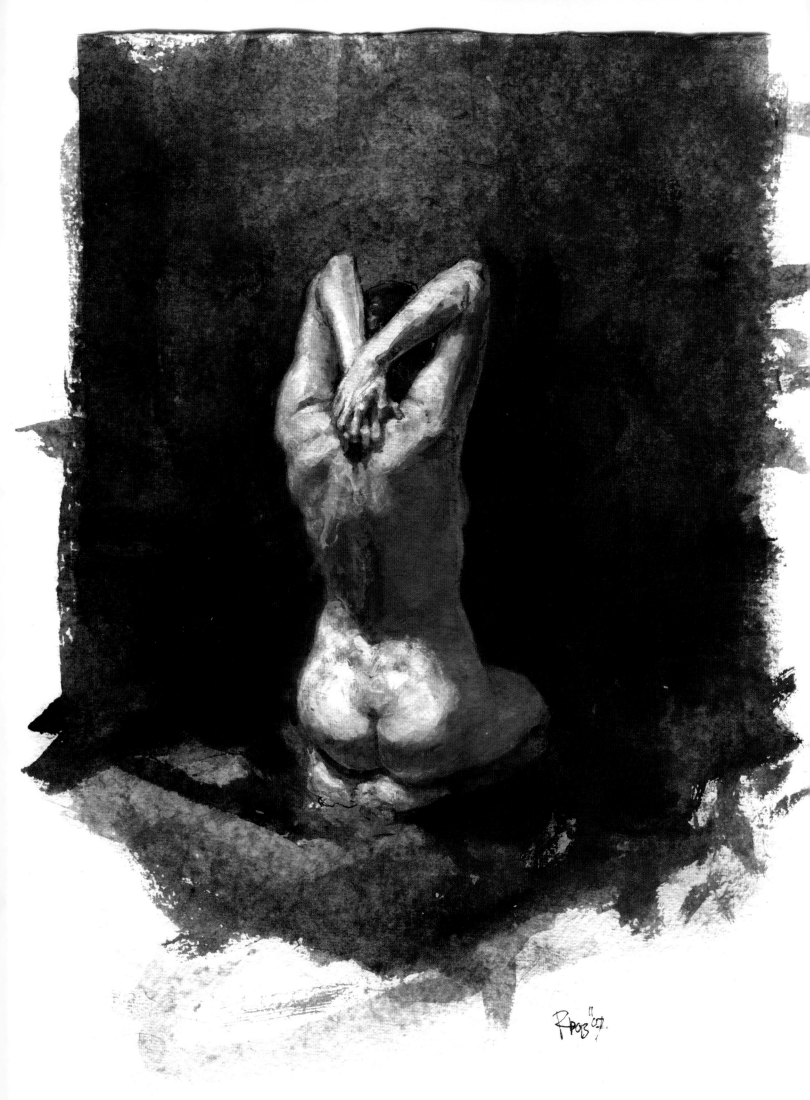

Counterweight - Rick O'Brien

Counterweight - Rick O'Brien

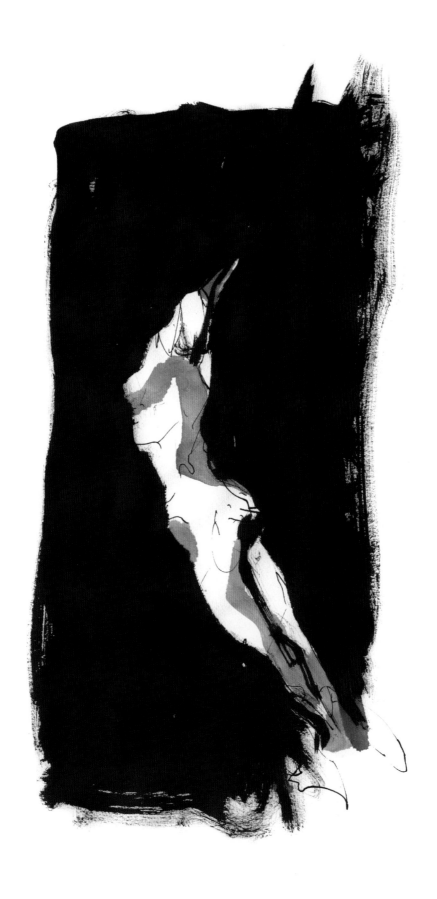

Counterweight · Rick O'Brien

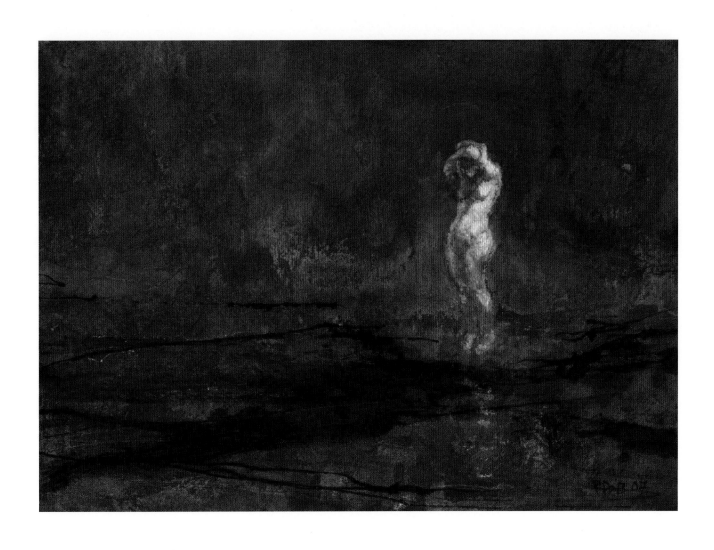

Counterweight - Rick O'Brien

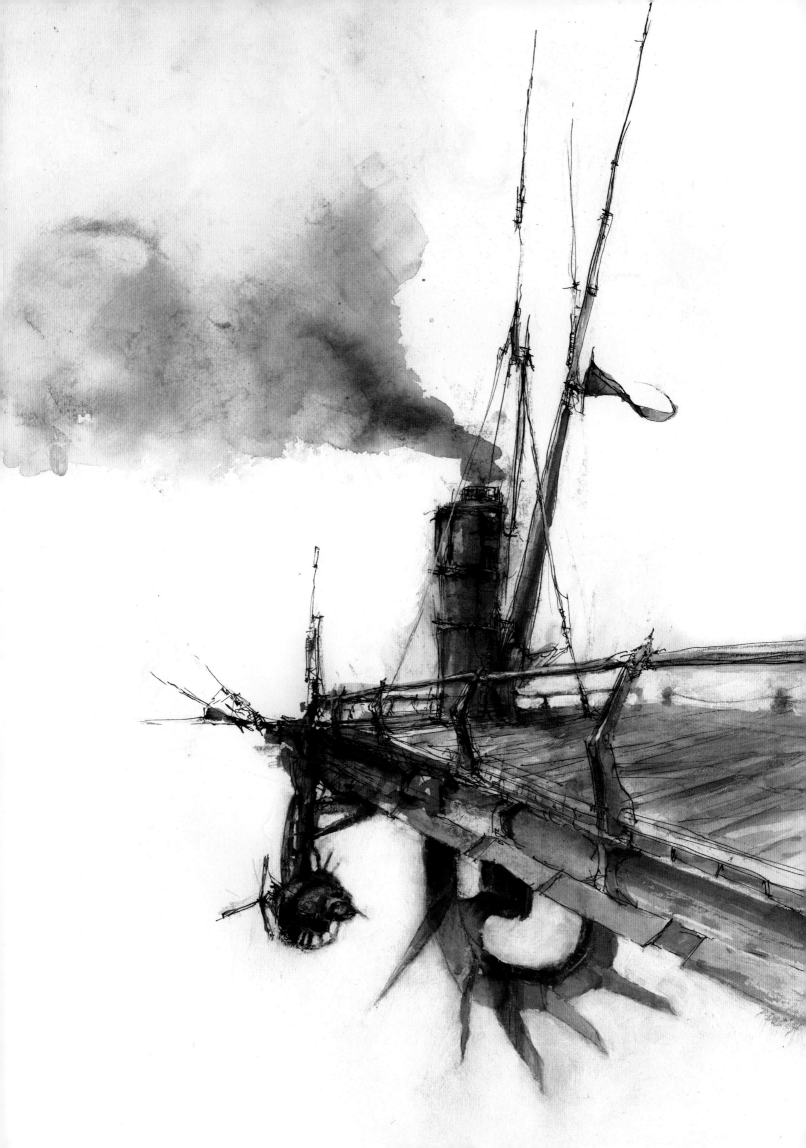

perspective through geography 2

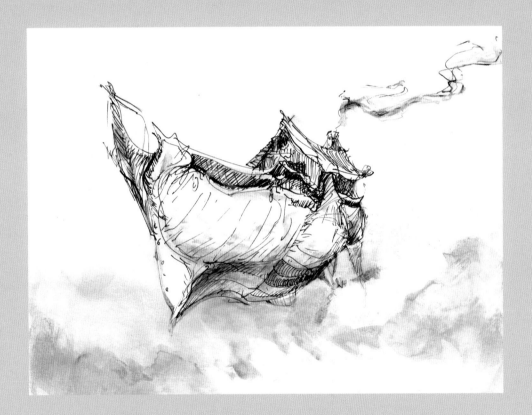

Perspective Through Geography follows a relationship, born from necessity, between a young lighthouse keeper, whose occupation and aspirations provide her with a fulfilling, yet solitary existence, and an aged longshoreman resigned to his work. Through correspondence, their bond and their perspectives on life choices, are tested. The isolation inherent in their fields becomes the proving ground for the impact that geography has on perspective.

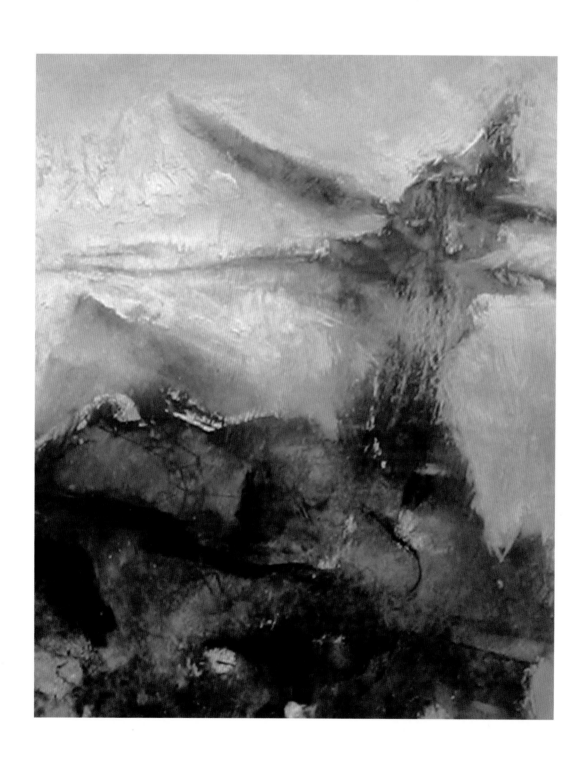

Counterweight - Rick O'Brien

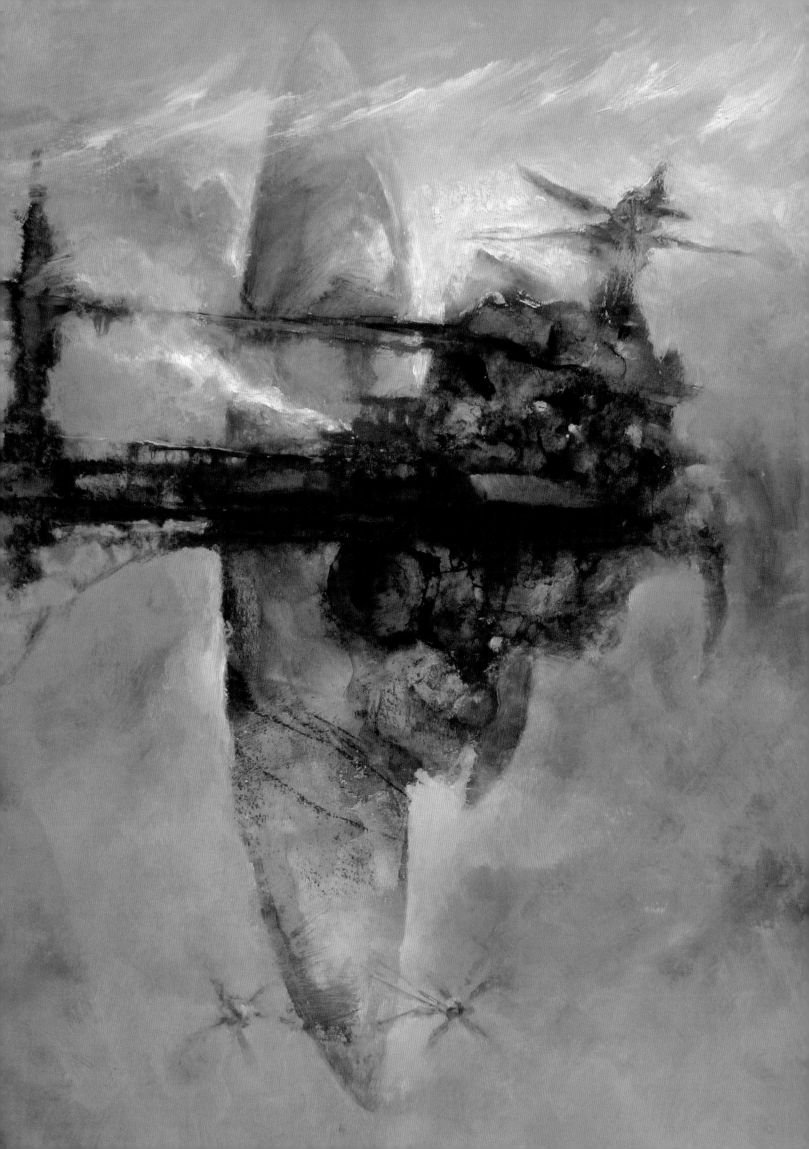

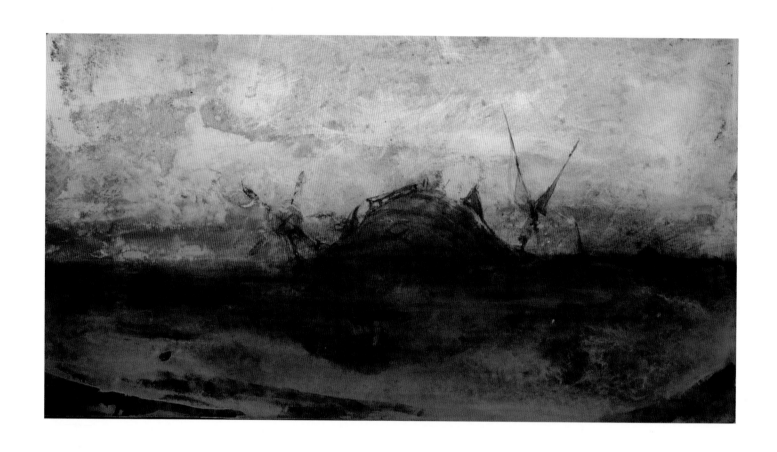

Counterweight - Rick O'Brien

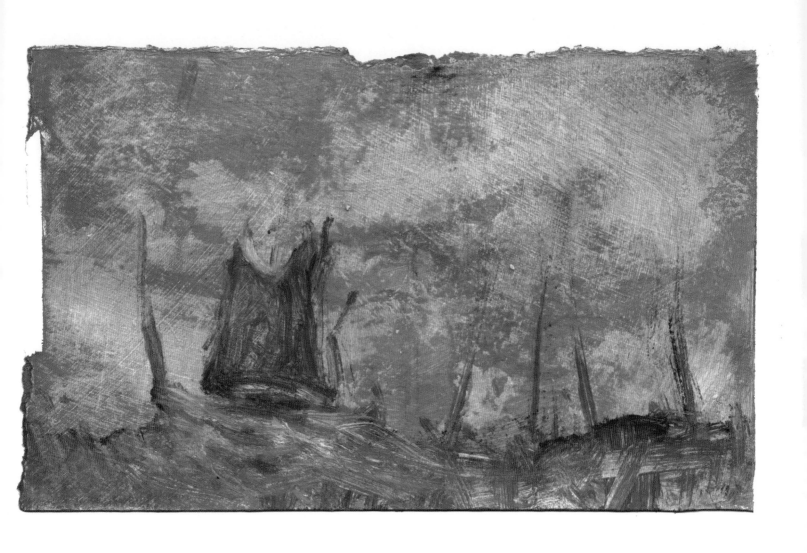

CounterWeight - Rick O'Brien

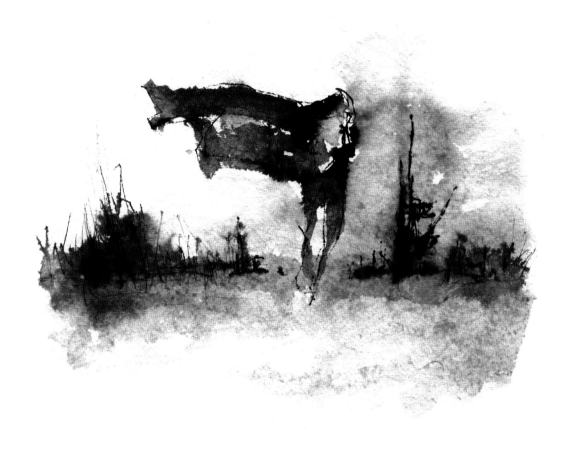

A trip to the market and my first 'new' home-cooked meal.

7.2 km to town.

The loudest sounds, I'm sure, are my own breathing and footsteps on the road.
All of my senses seem heightened.
I can feel the cold air in my chest and heartbeat in my ears.
Even so, kilometers pass easily along the coastline.
Each rise and fall of the green hills is a welcome companion in my new life.
Color-coded sheep are everywhere, along with the *remembrances* they leave behind!
The town is just ahead.
I wonder if they have spaghetti sauce?

Journal excerpt
Observation Post 019 co. DK

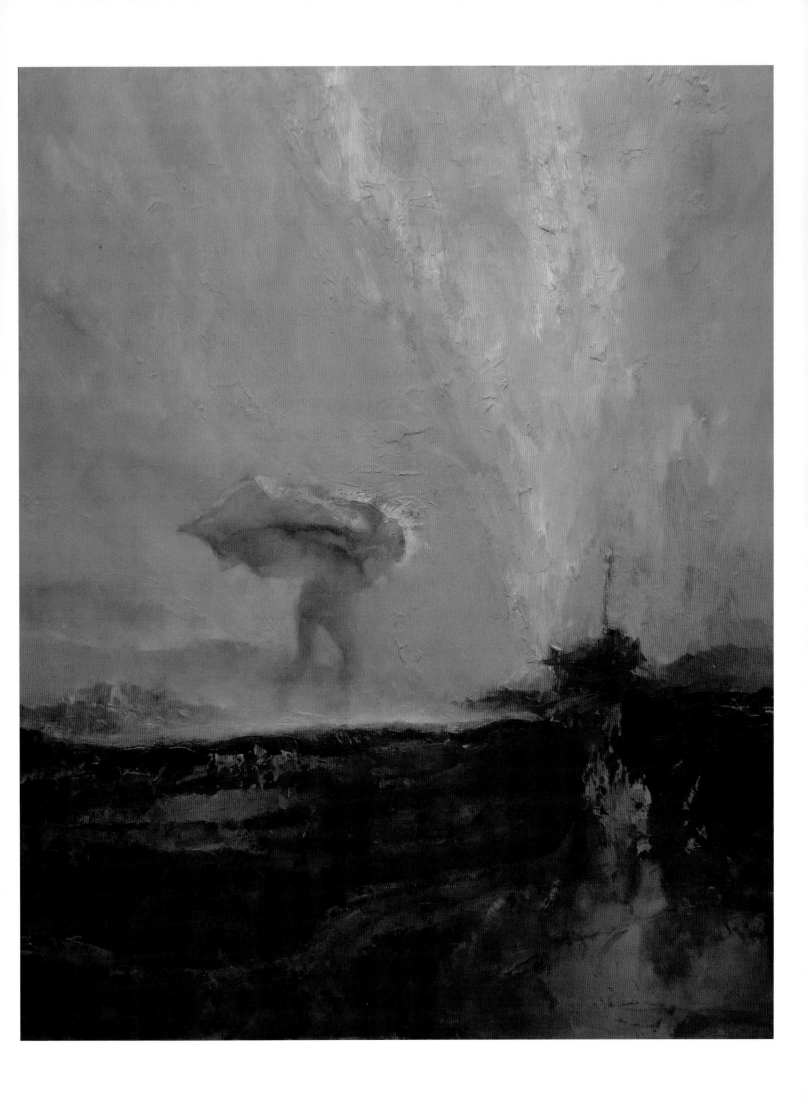

Counterweight - Rick O'Brien

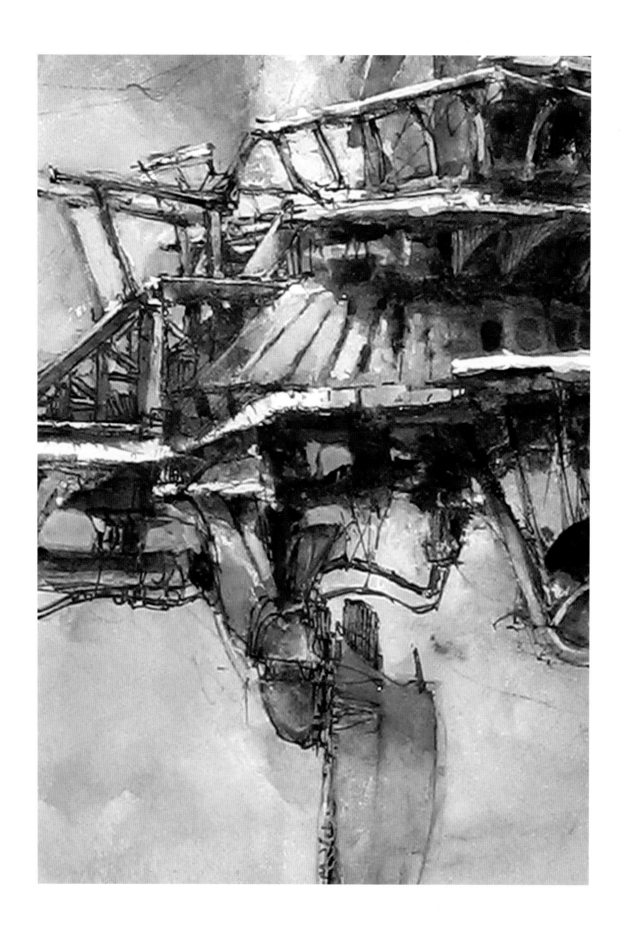

CounterWeigHt · Rick O'Brien

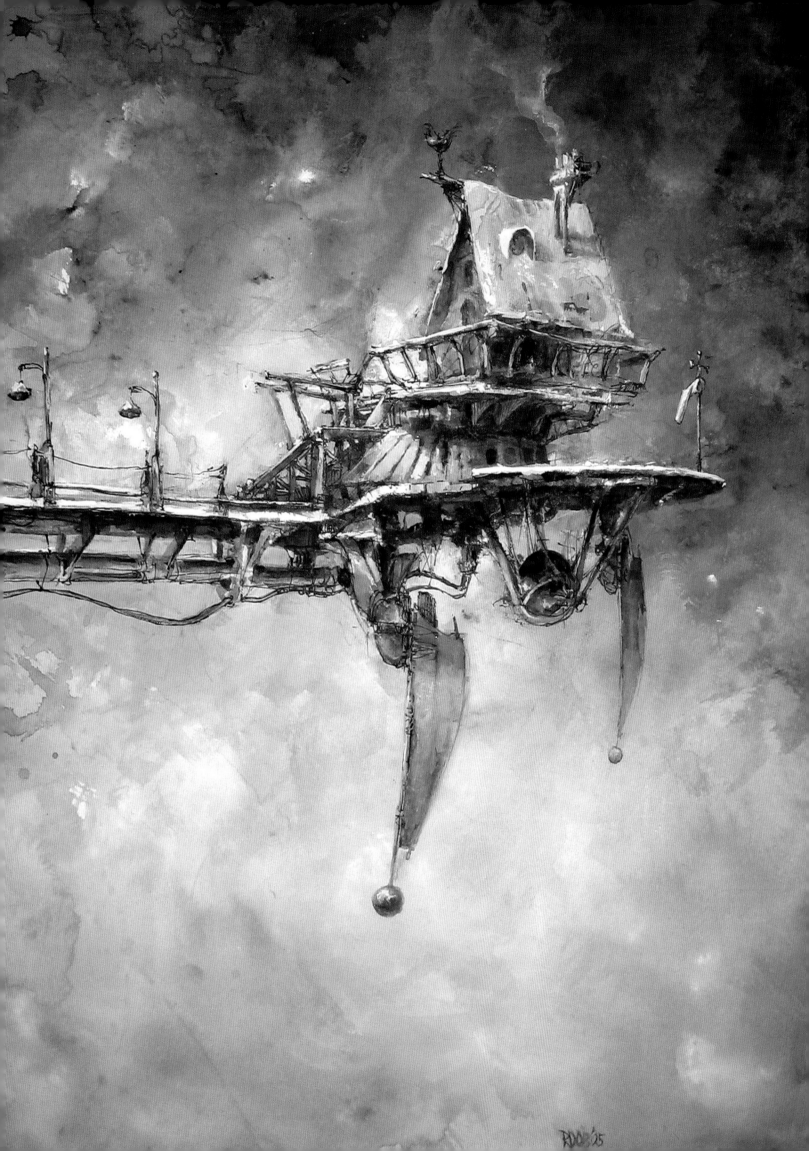

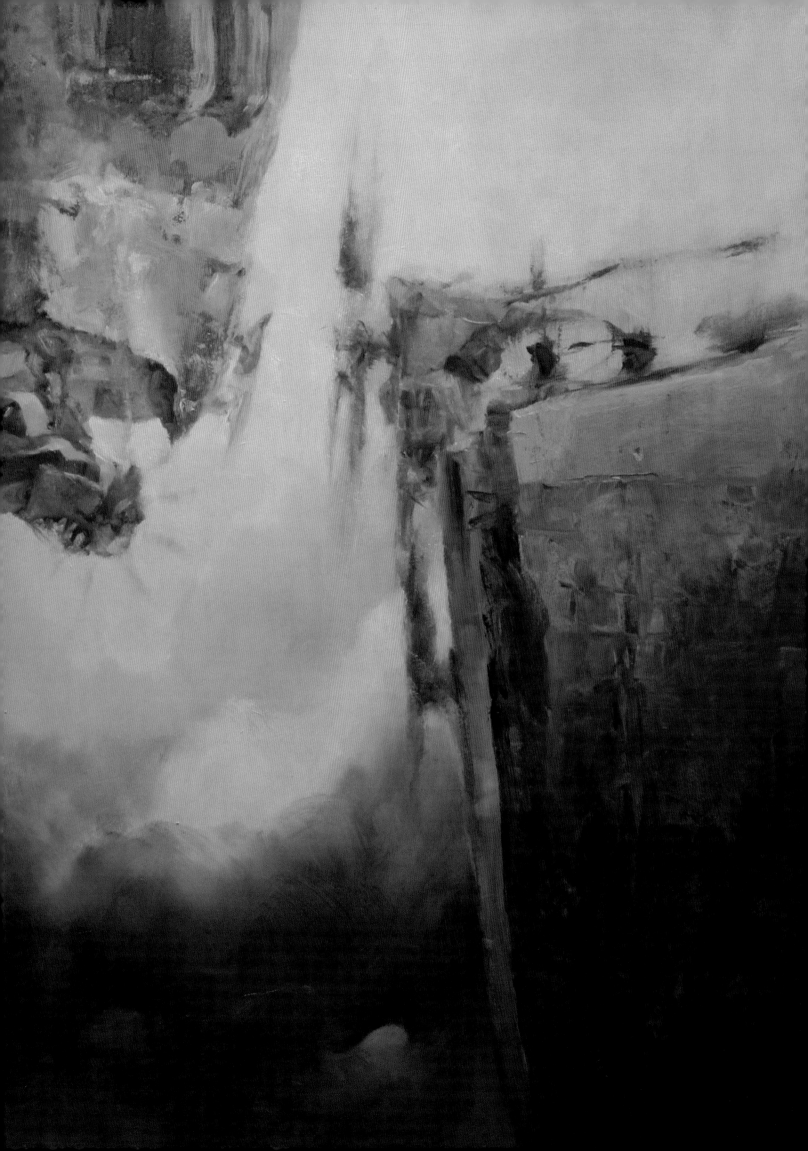

Dear Sir,

Thank you for the advice.
That was the best spaghetti with butter and coffee I've ever had.

The wind is strong here.
I often find myself lifted from the path,
struggling to keep within the ruts.
But my new post is exciting…and cold…and loud…
I know that this structure is sound,
though it feels like a fort made out of cushions.
I'm sure it will be fine.

Warm Regards,

Observation Post 019 co. DK

Counterweight - Rick O'Brien

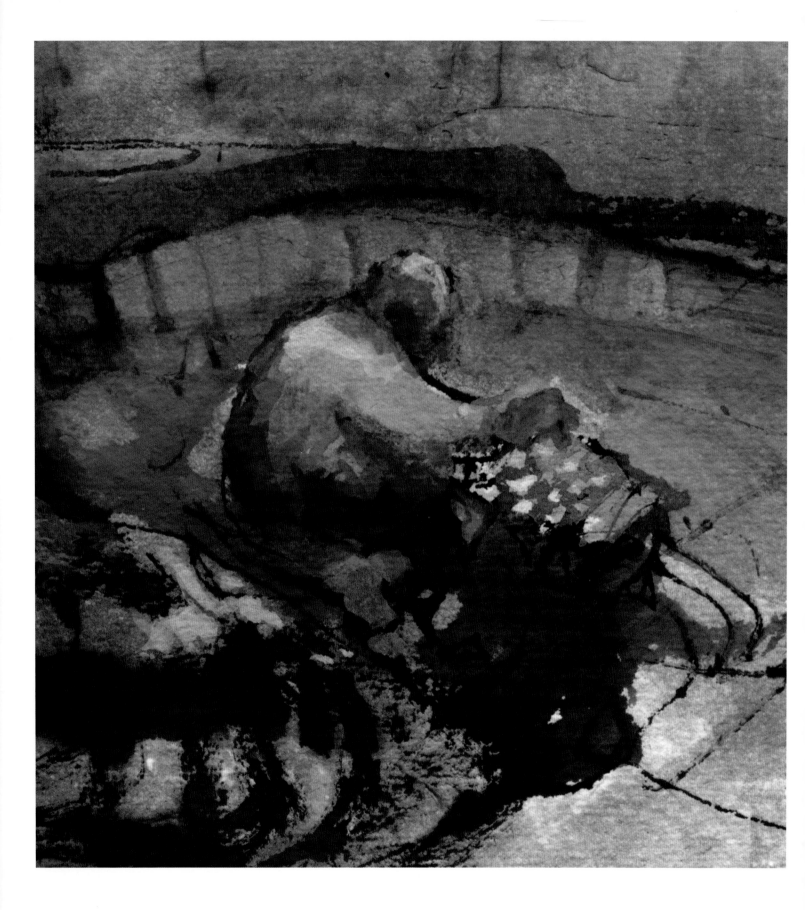

"…The solitude I signed on for has its price.

My schedule, though rich with study, lacks distraction.

Well, I suppose it has built-in character, but it always feels like work here…"

OP-019 co.DK

COUNTERWEIGHT - Rick O'Brien

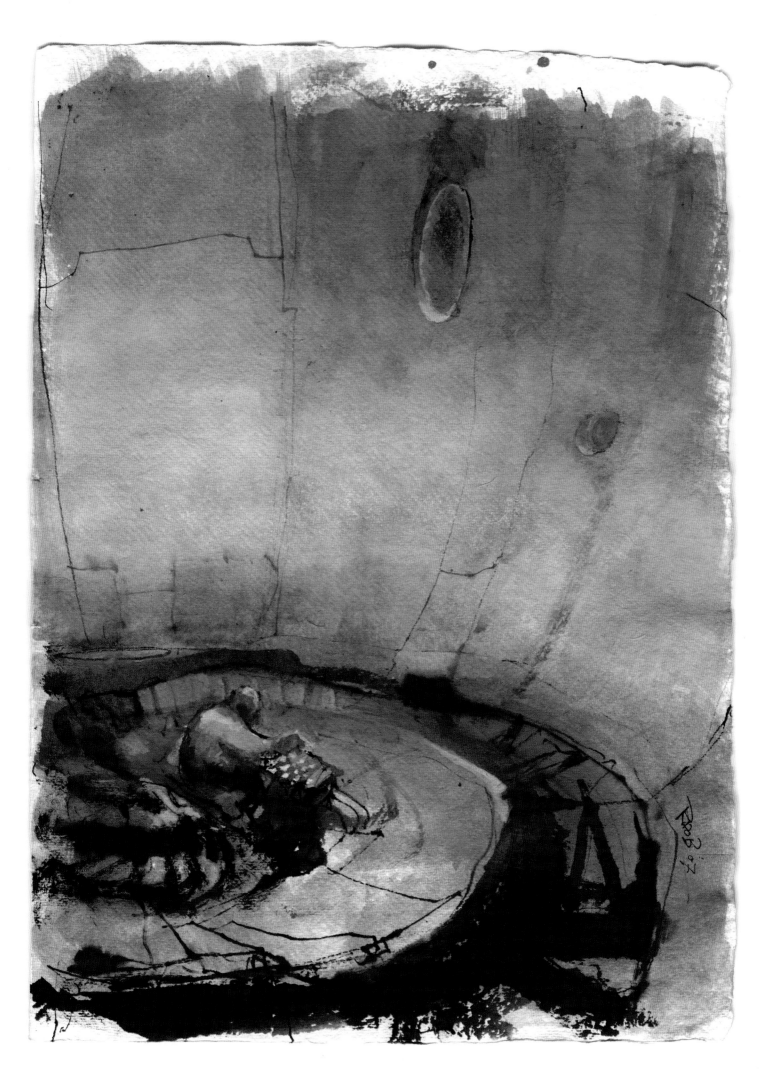

Counterweight - Rick O'Brien

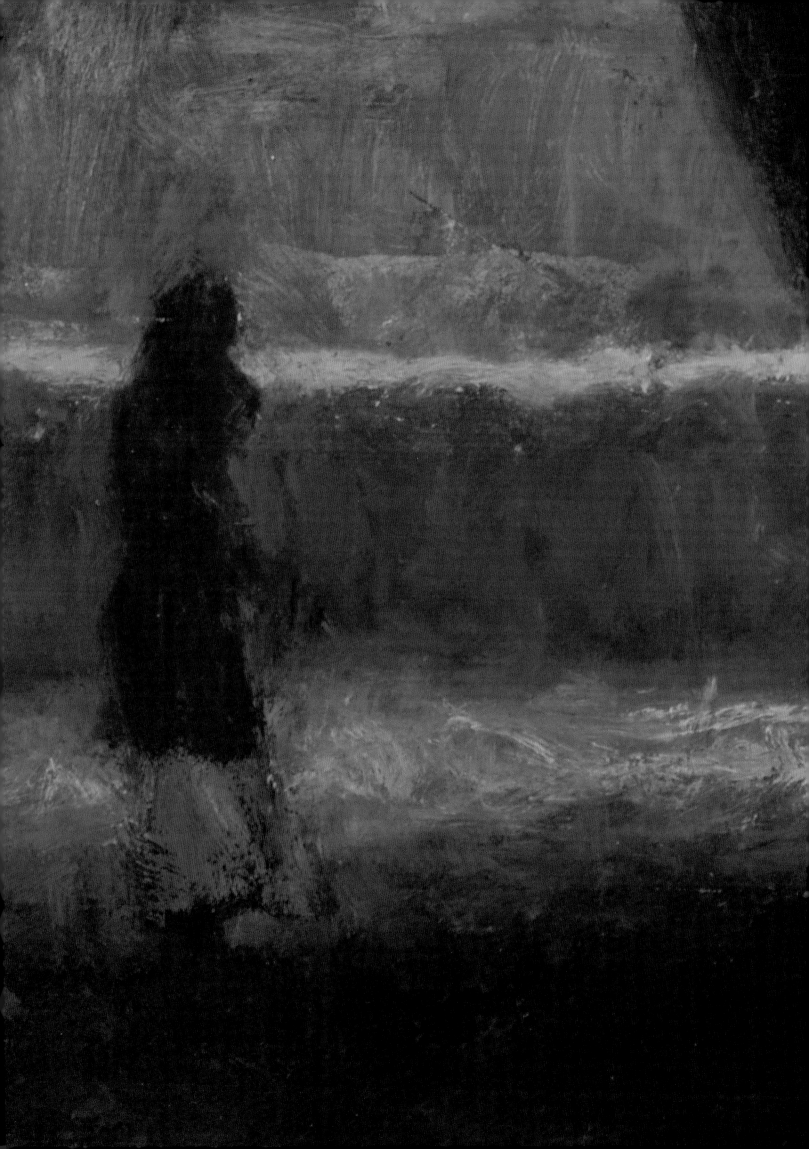

the range of humanity 3

The sum of who we are is the foremost aim of this work-in-progress. *The Range of Humanity* is an ongoing survey which maps the human experience through metaphor.

The roots of this study date back several years to a period when my technical growth and creative vision vied for attention. Initially, the concept took on a more traditional and literal structure. Characters reacted to situations and each other in a tangible environment. The story revolved around an inventor, his daughter, and a character known as Five. More or less the victim, Five was an ongoing experiment and vehicle for the father's ambitions, as well as a source of sympathy and compassion for the girl. As the work and vision matured, I began to feel increasingly tied down by the dynamics of the literal framework in which I'd enclosed myself. The common thread, however, had always remained the same. Five embodied Man's struggle and the center of all things natural. He became the manifestation of human weakness and fortitude. Through the exploitation of symbolism, namely armor, the notion of wearing one's identity has become a constant and remains the focus of this study.

The Range of Humanity explores the tapestry of human behavior, and is ultimately an introduction to the players of *OUR* story.

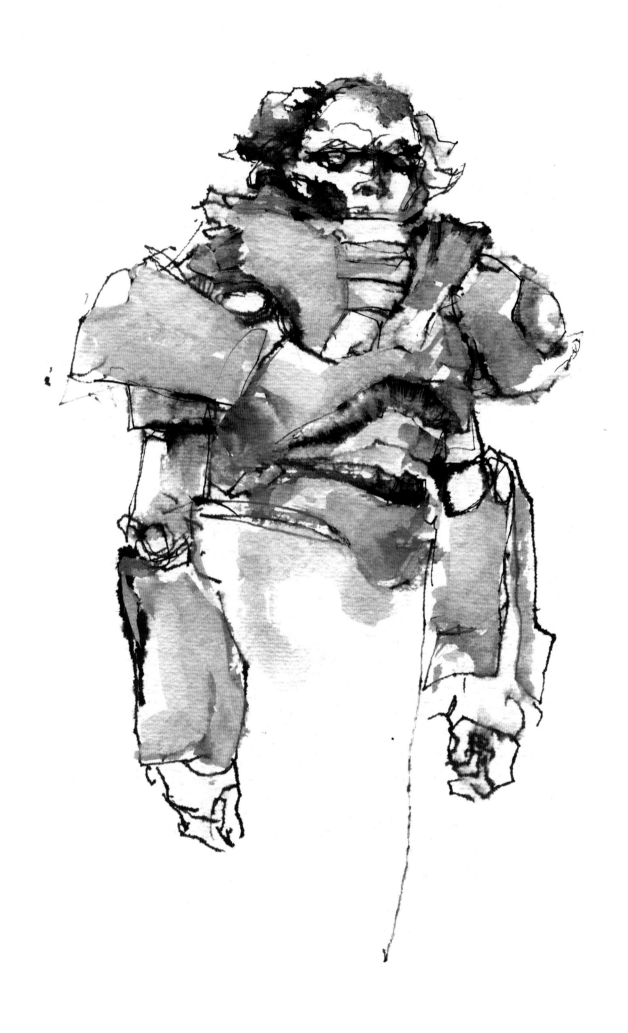

Counterweight - Rick O'Brien

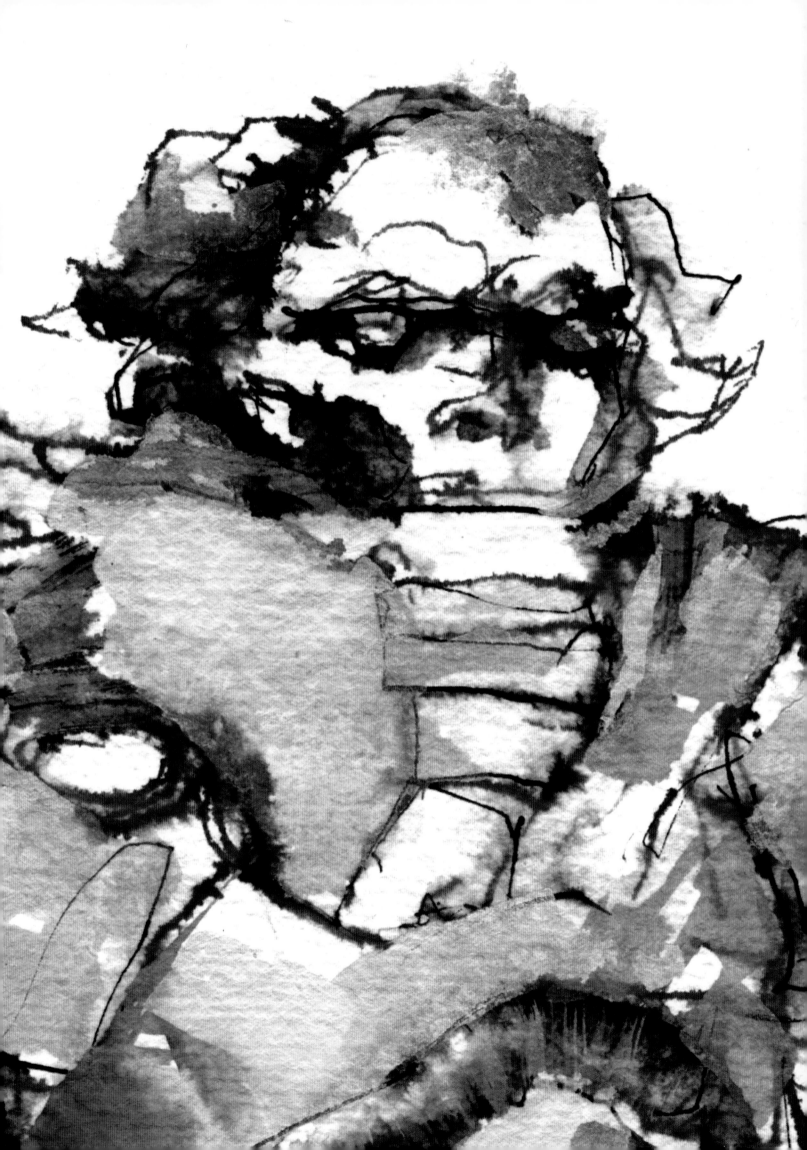

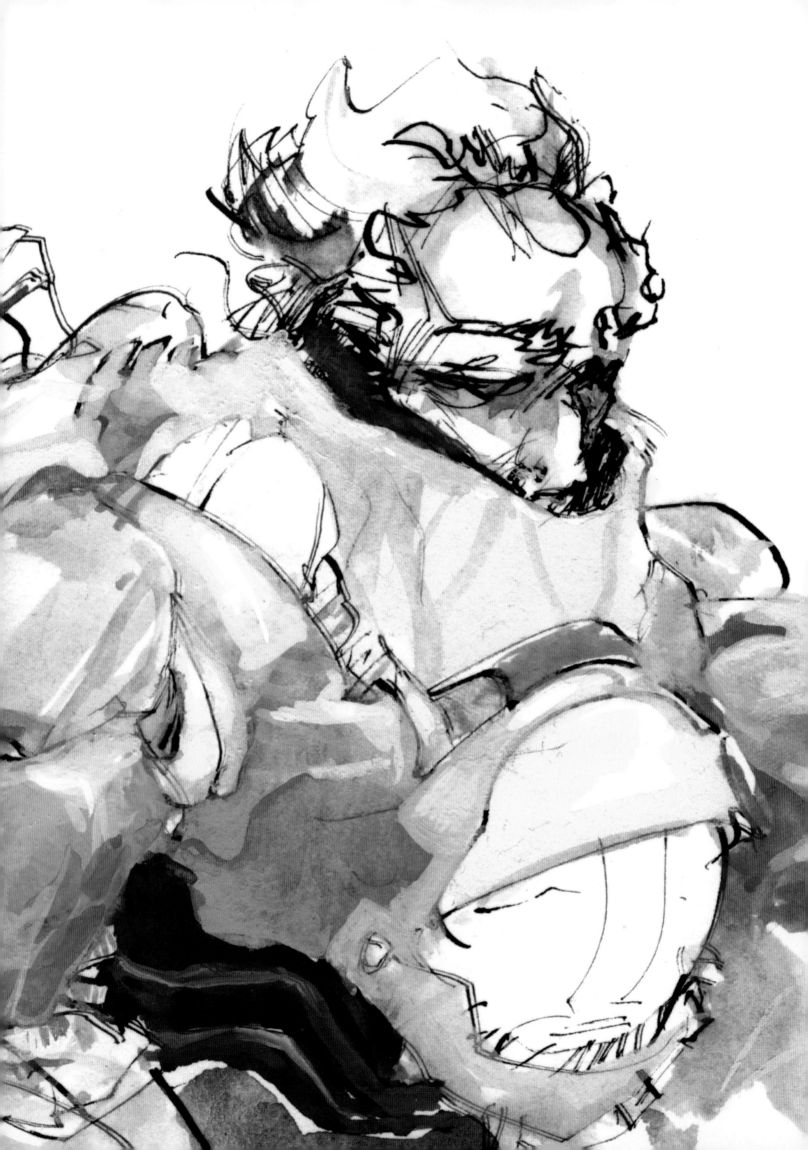

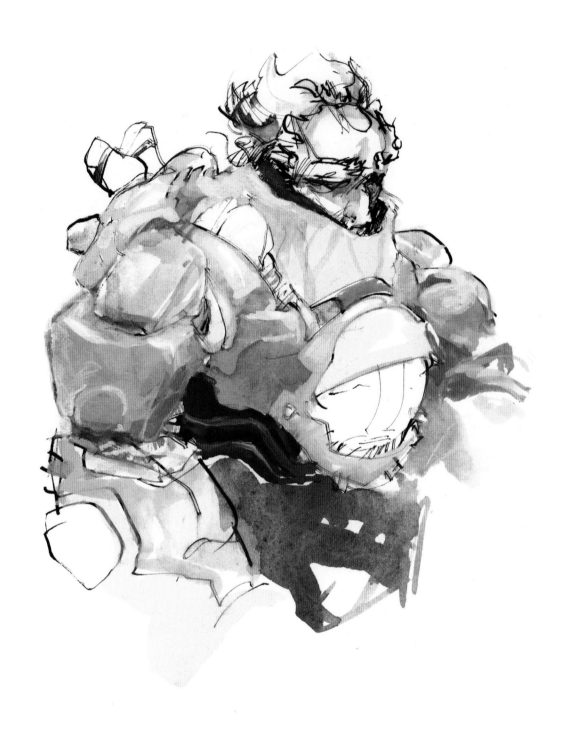

Counterweight - Rick O'Brien

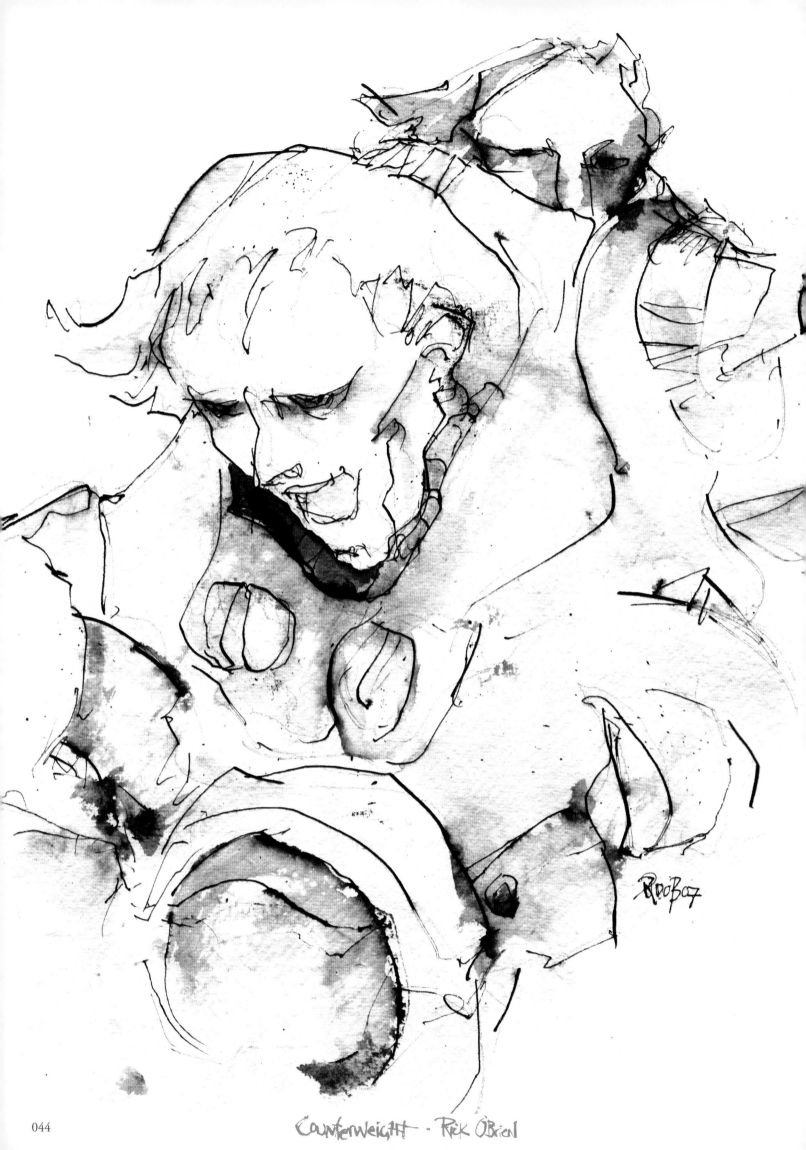

Counterweight - Rick O'Brien

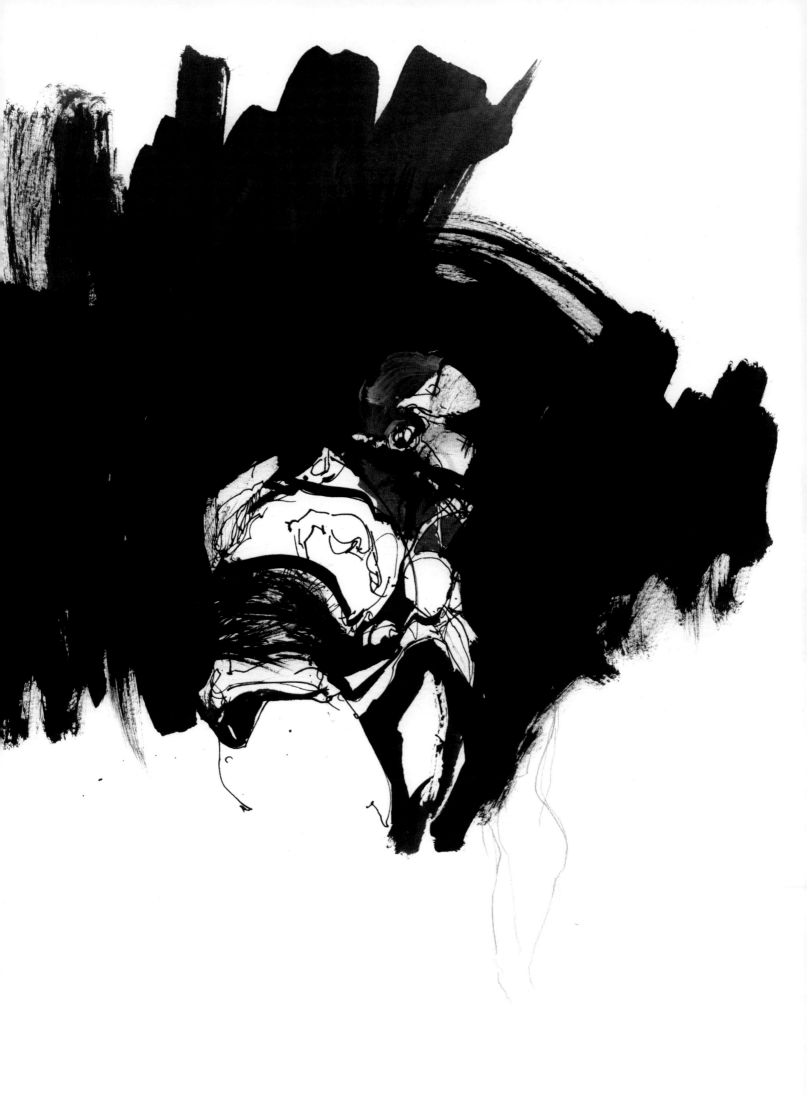

Counterweight - Rick O'Brien

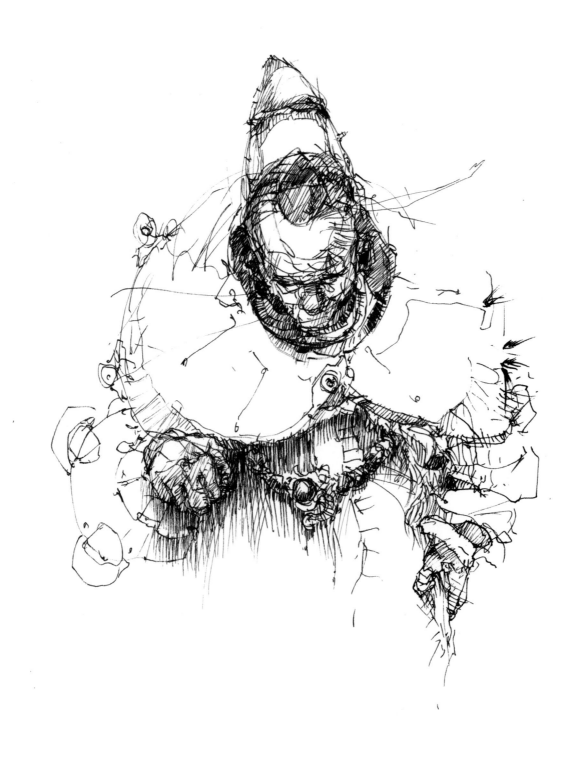

046 Counterweight · Rick O'Brian

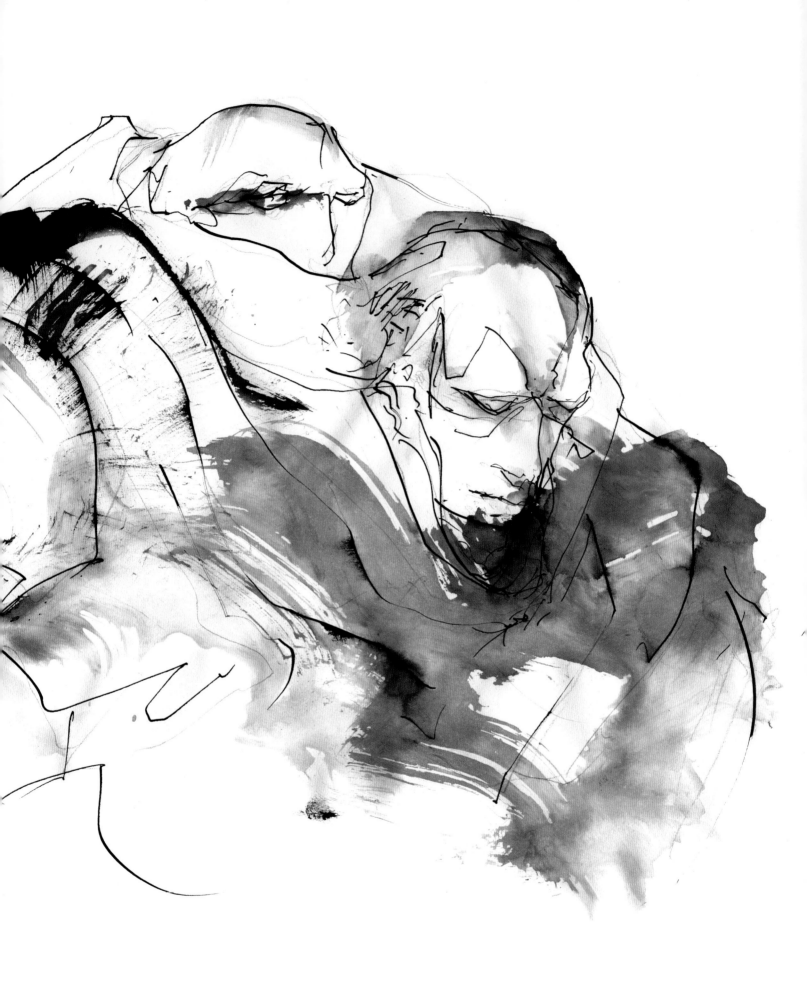

Counterweight - Rick O'Brien

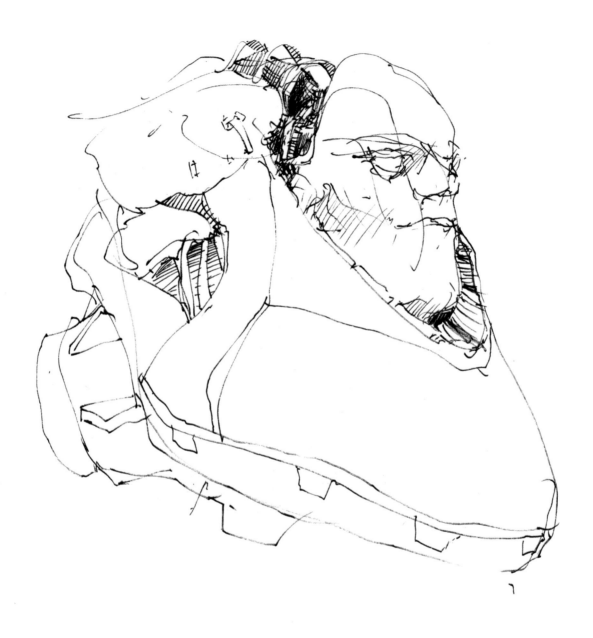

Counterweight - Rick O'Brien

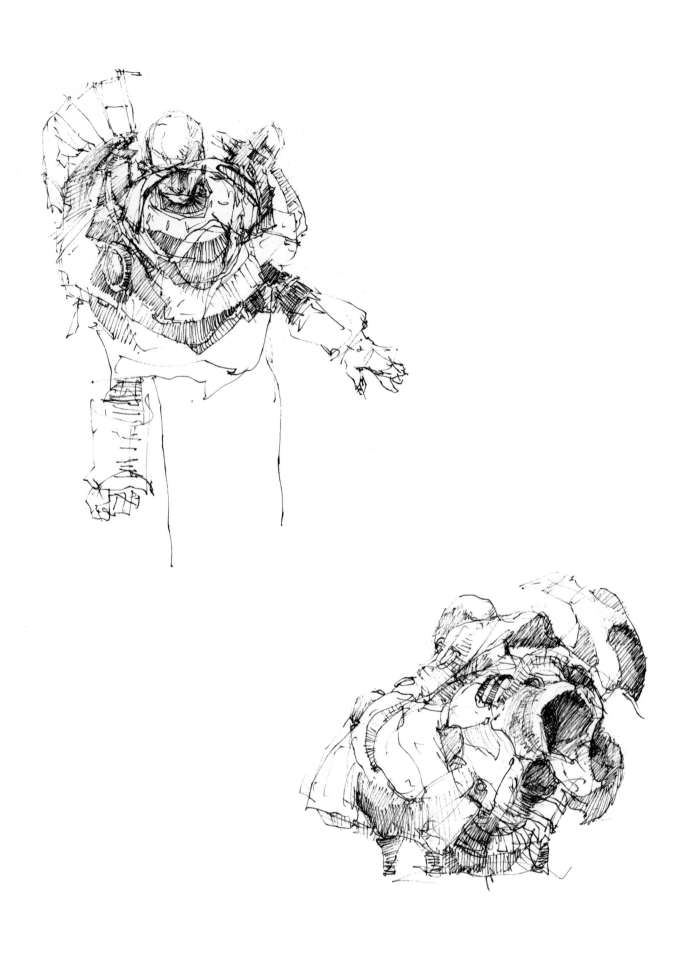

Counterweight - Rick O'Brien

050

Counterweight - Rick O'Brien

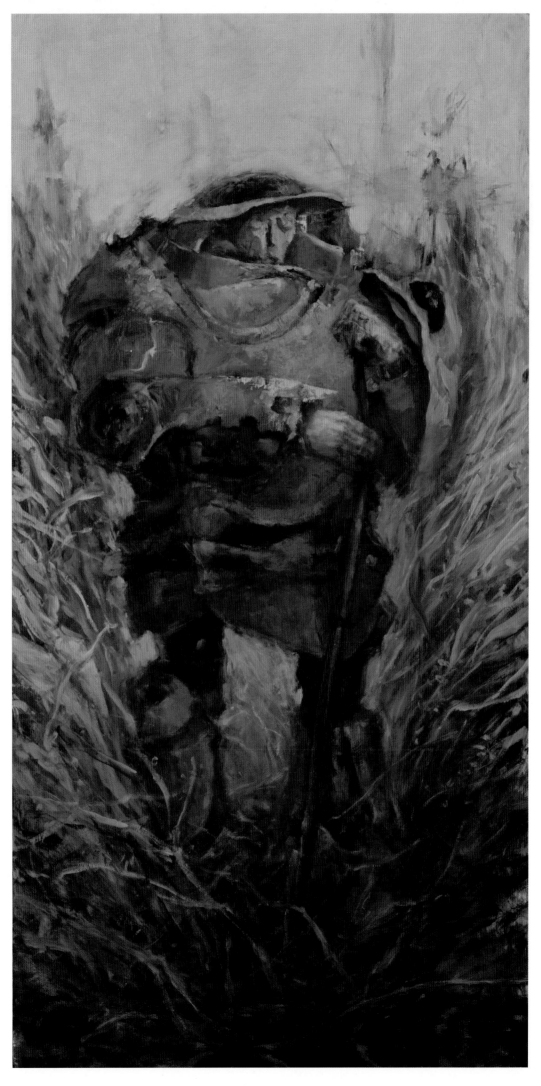

Counterweight - Rick O'Brien

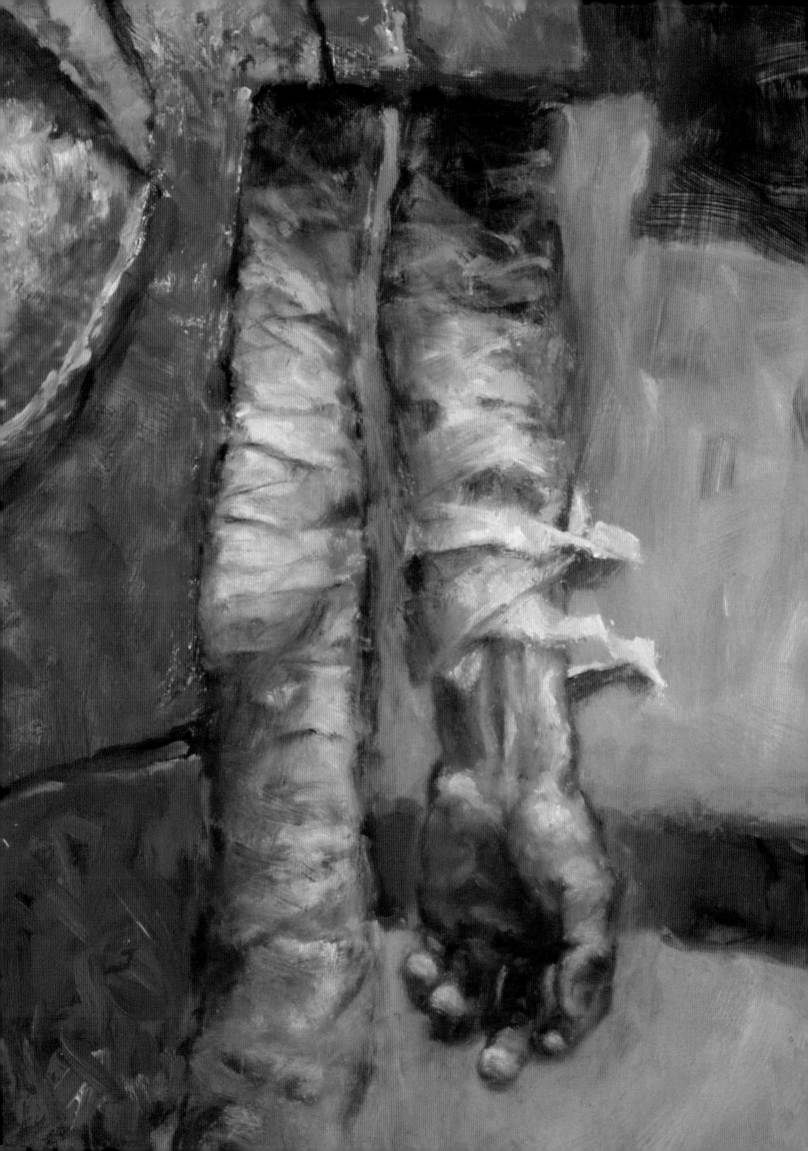

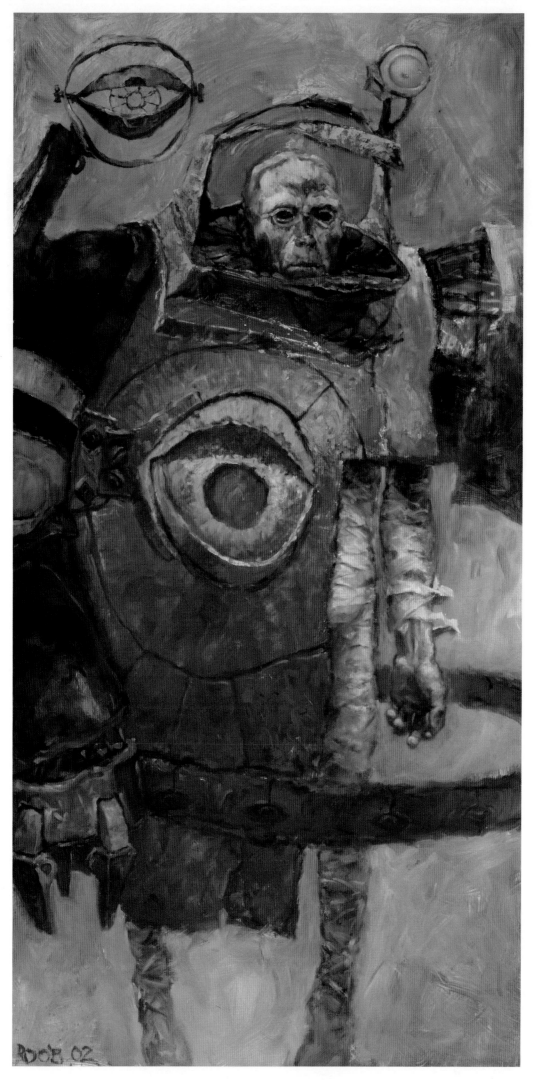

Counterweight - Rick O'Brien

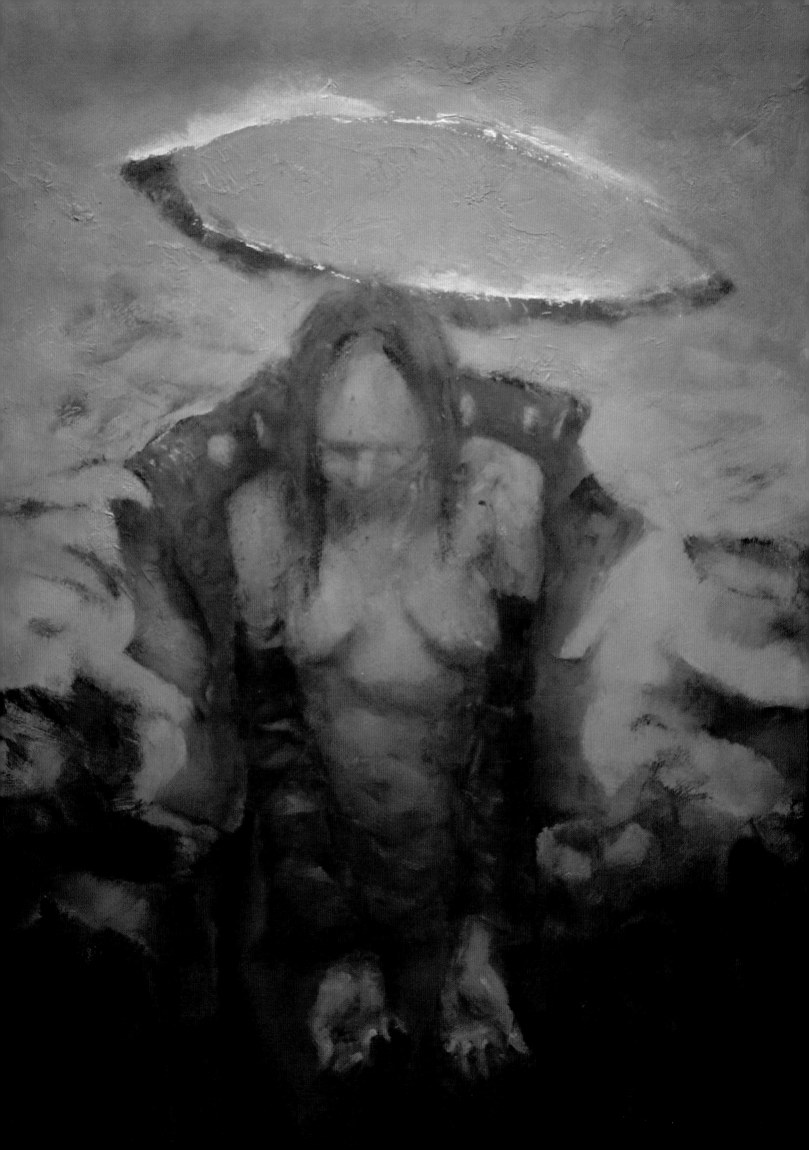

Counterweight - Rick O'Brien

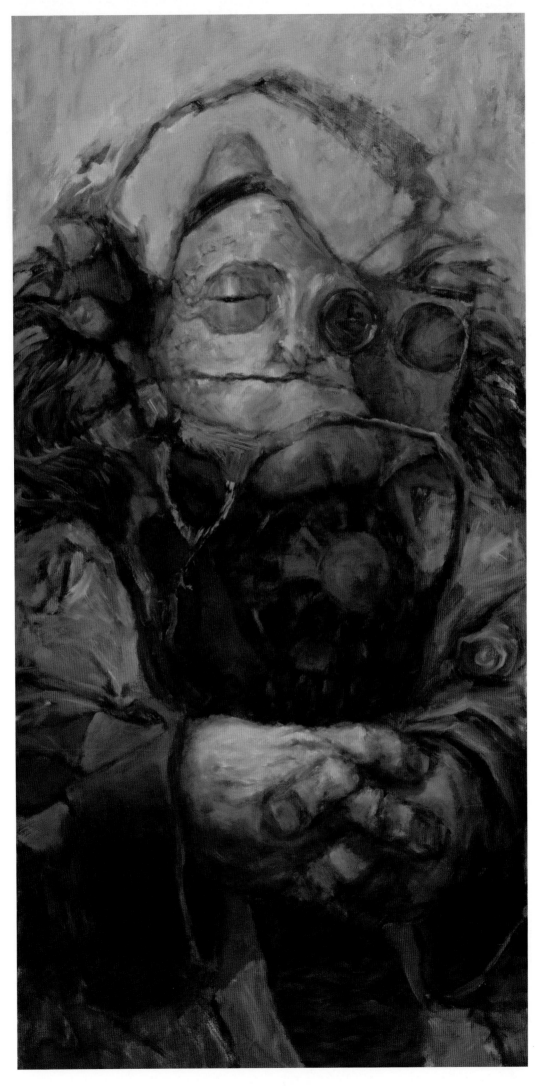

Counterweight - Rick O'Brien

057

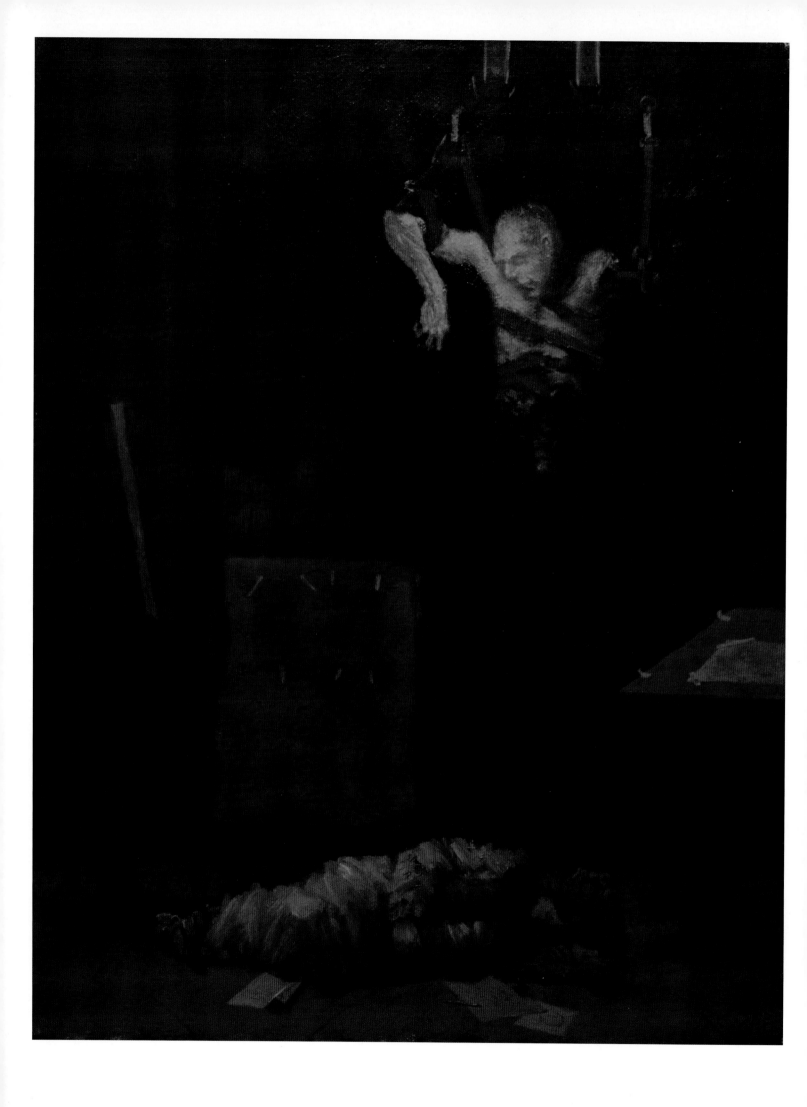

Counterweight - Rick O'Brien

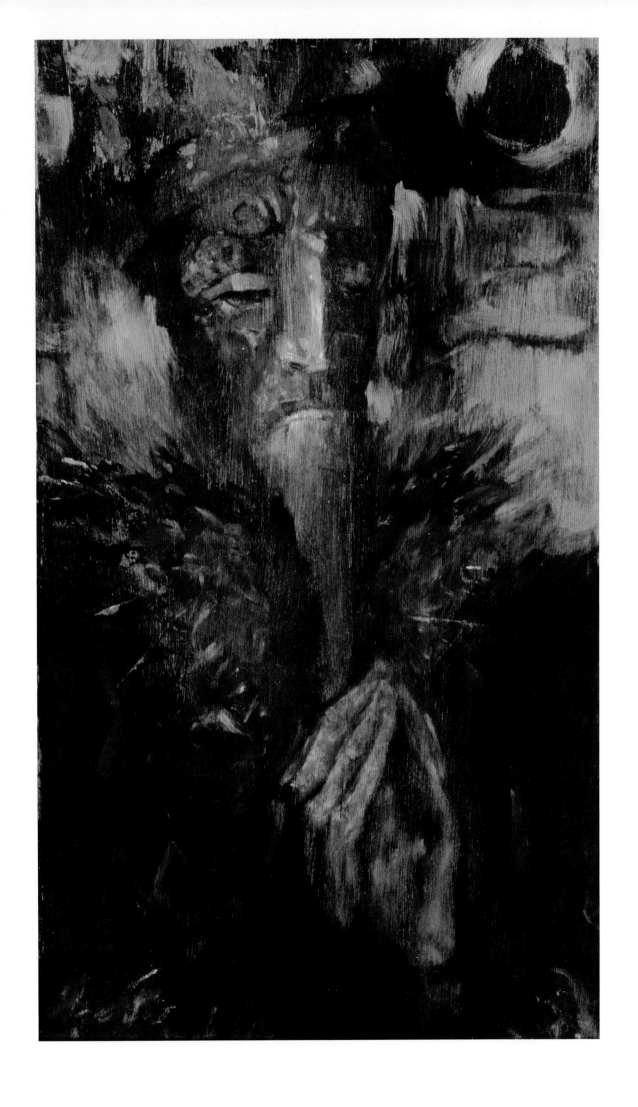

Counterweight - Rick O'Brien

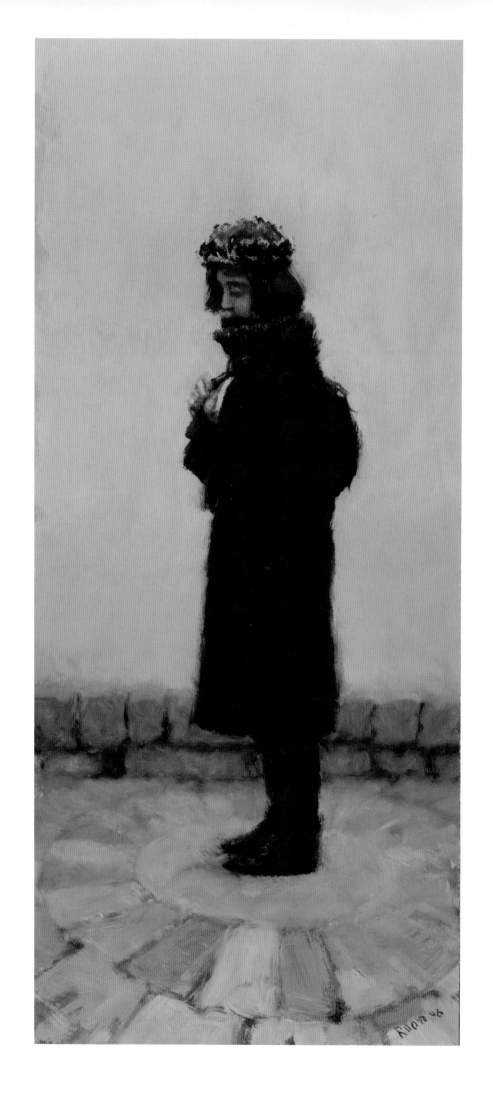

Counterweight - Rick O'Brien

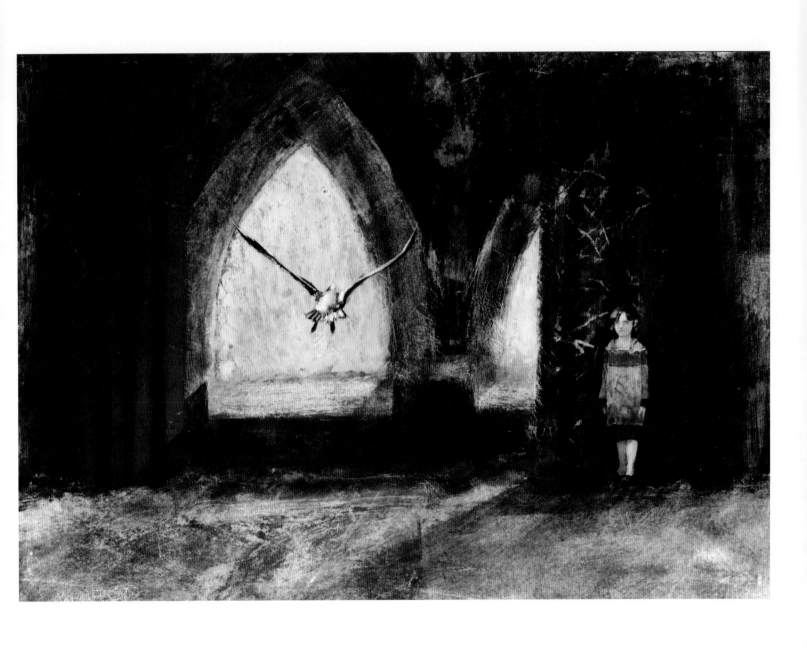

Counterweight - Rick O'Brien

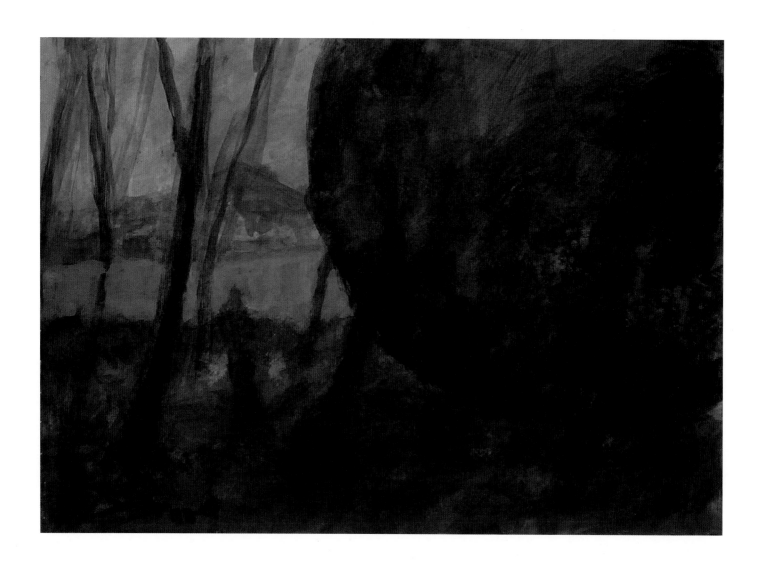

Counterweight - Rick O'Brien

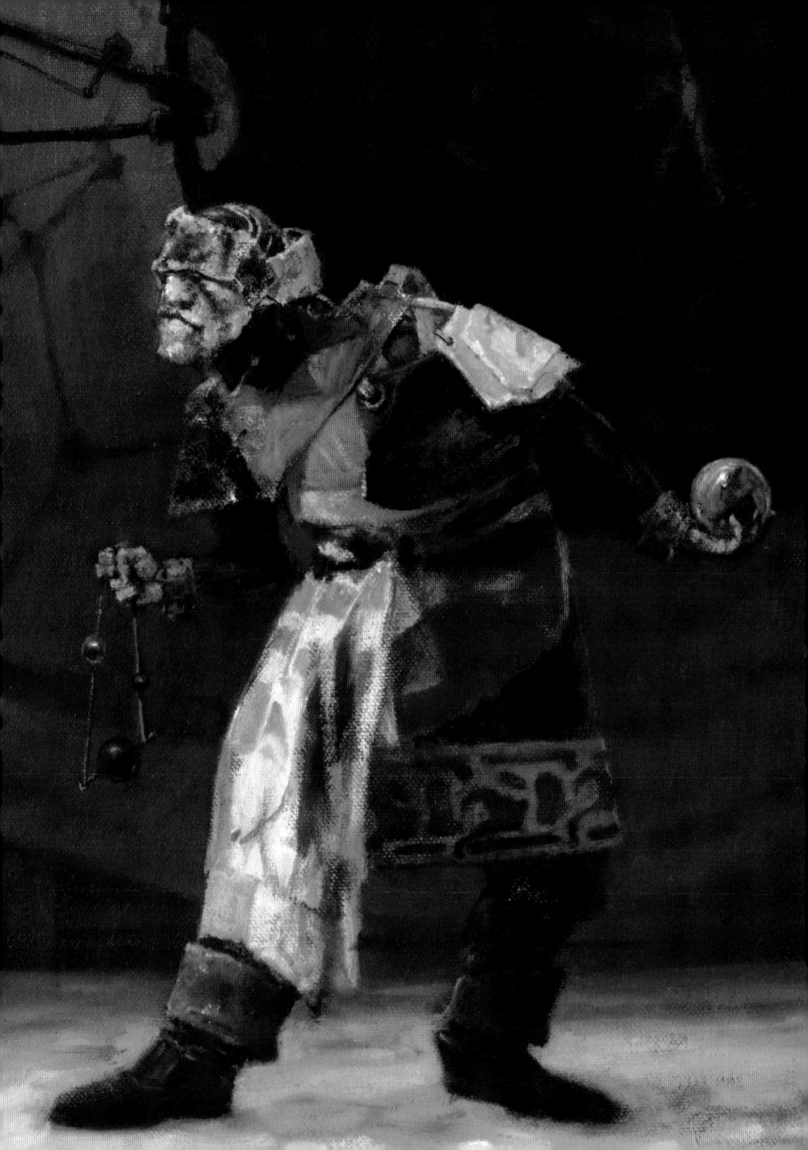

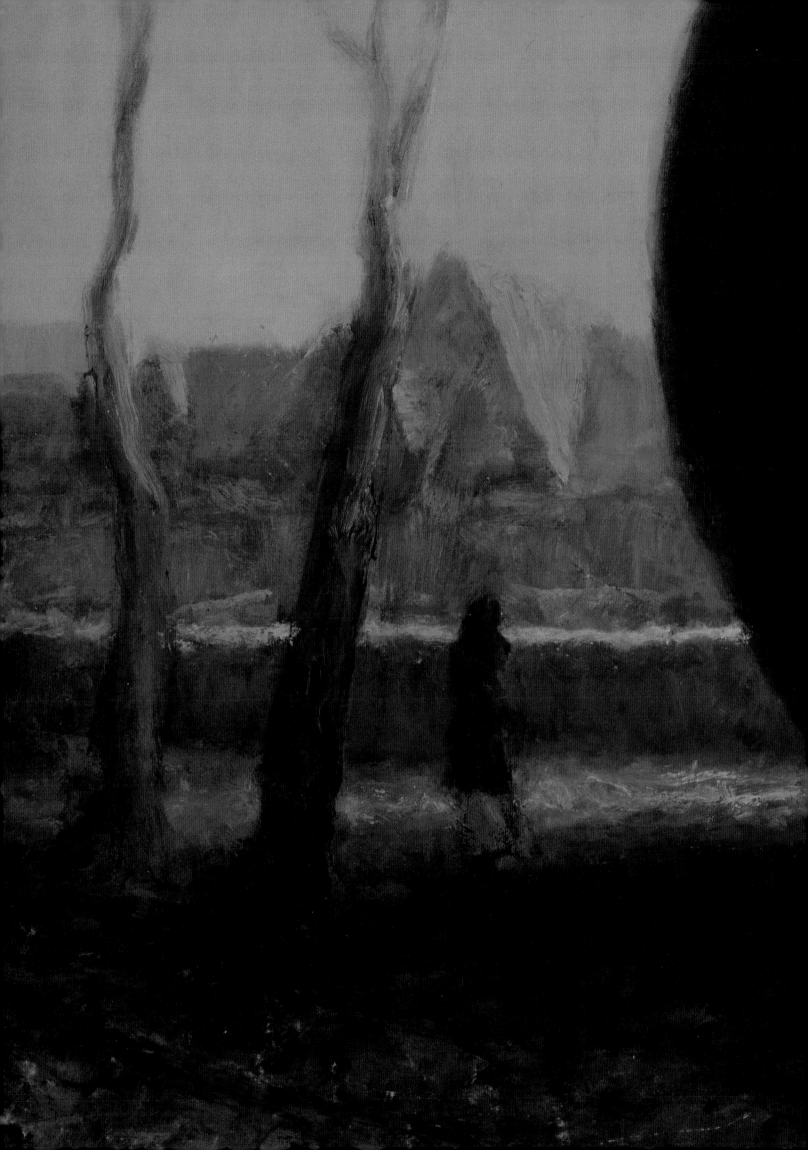

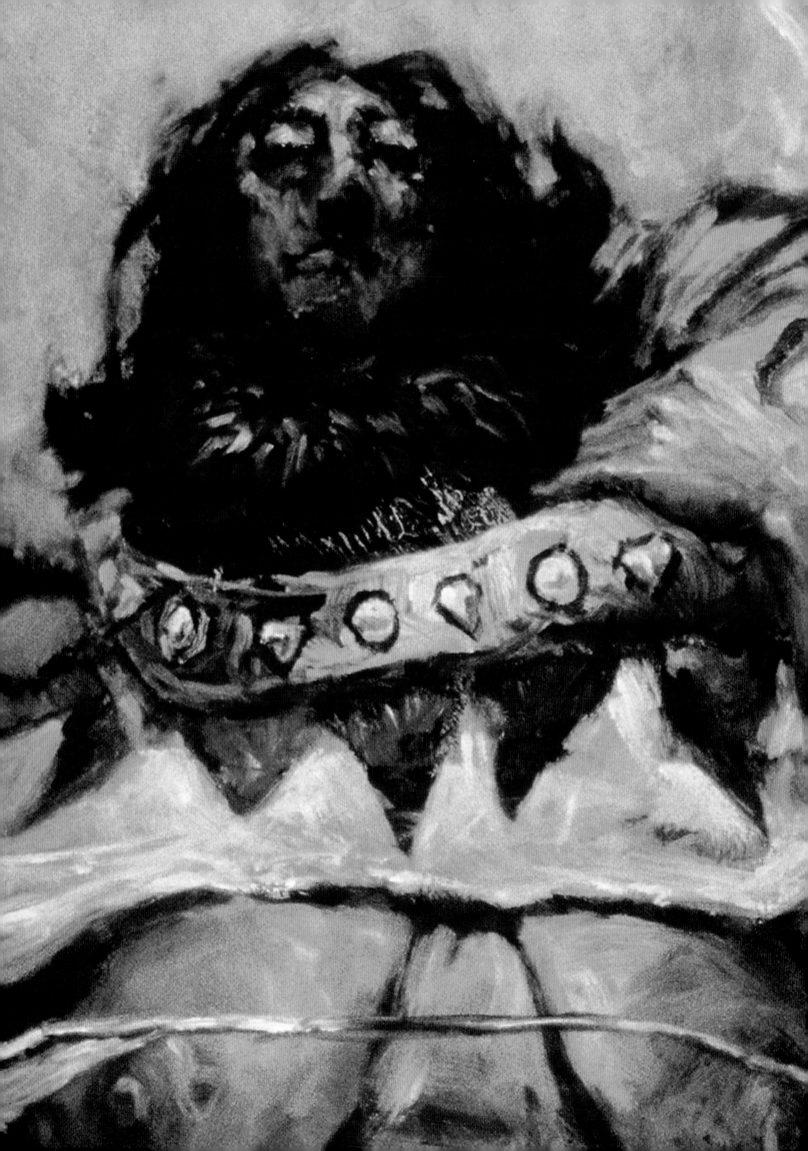

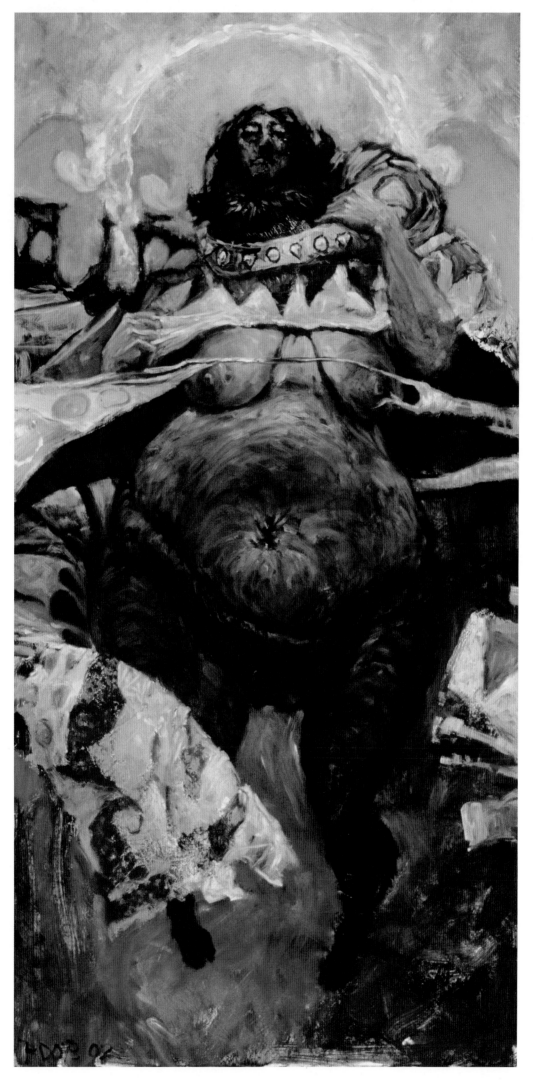

Counterweight - Rick O'Brien

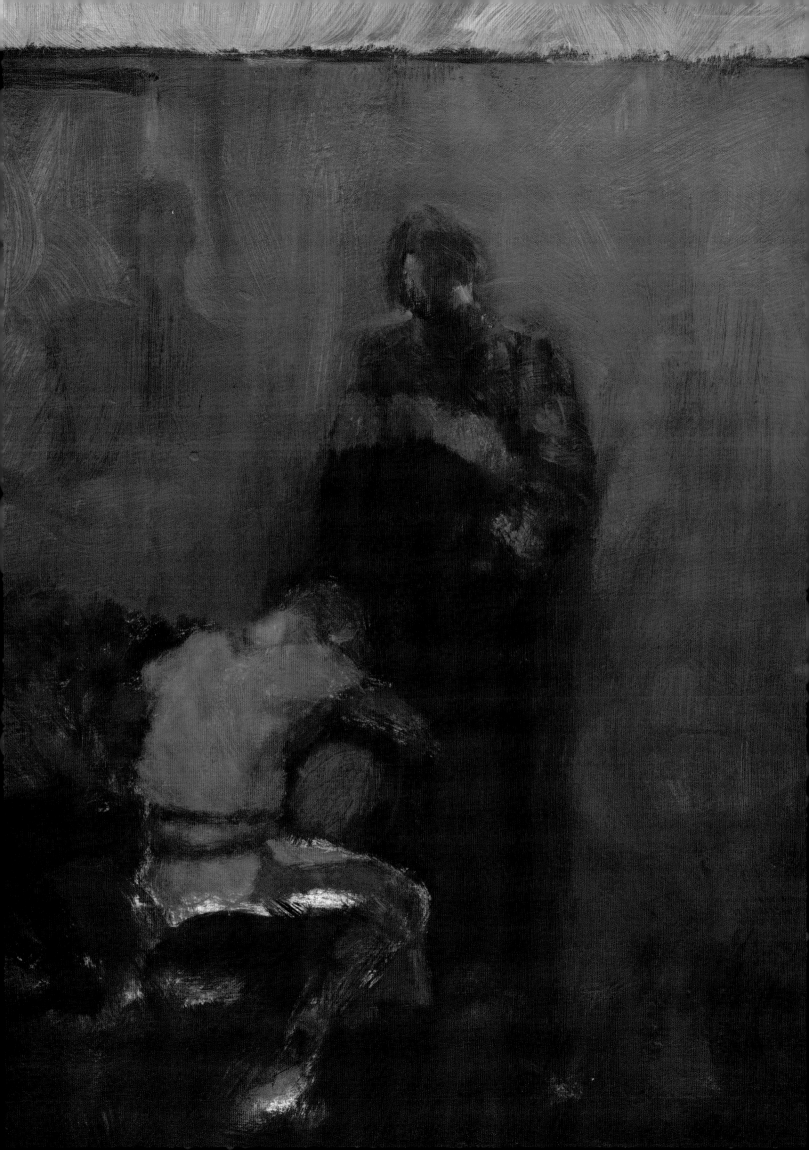

peripheral 4

Peripheral includes a tapestry of works, observations, assessments, and representations of *OUR* condition, spanning personal discovery, secondhand experience, and thirdhand accounts of truth, ambition, love, invention, divinity, responsibility, beauty and other concepts just left of *certainty*.

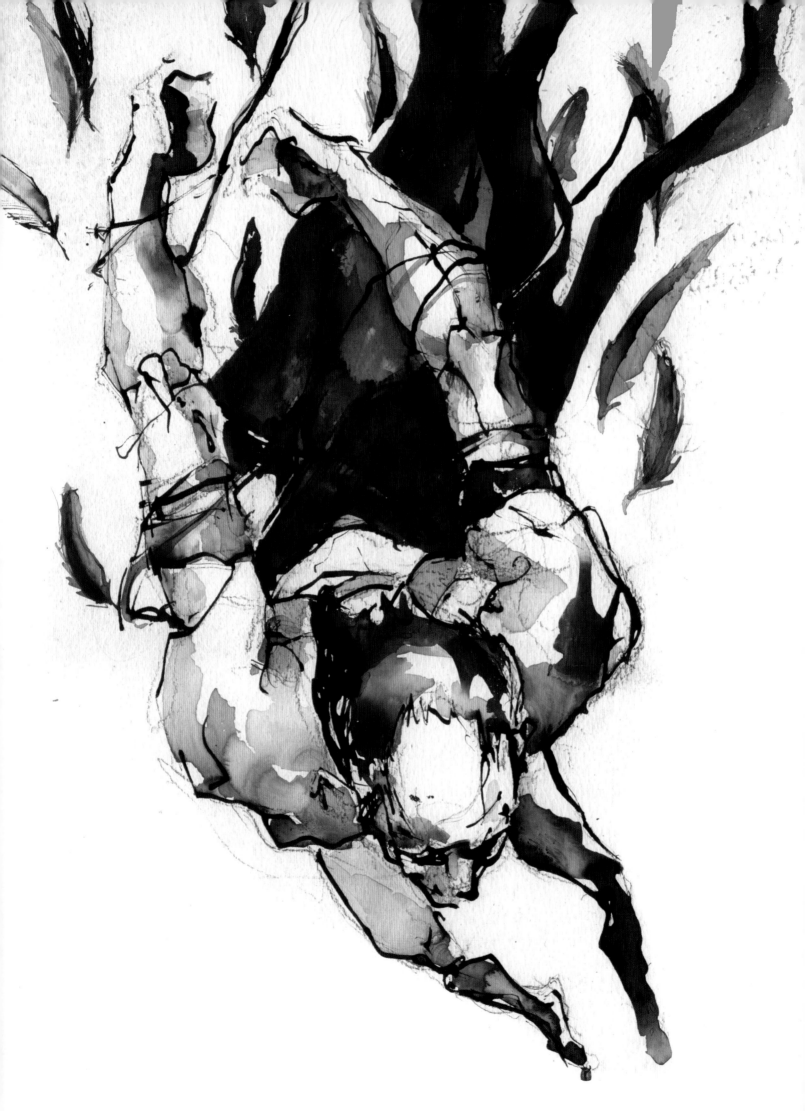

Counterweight - Rick O'Brien

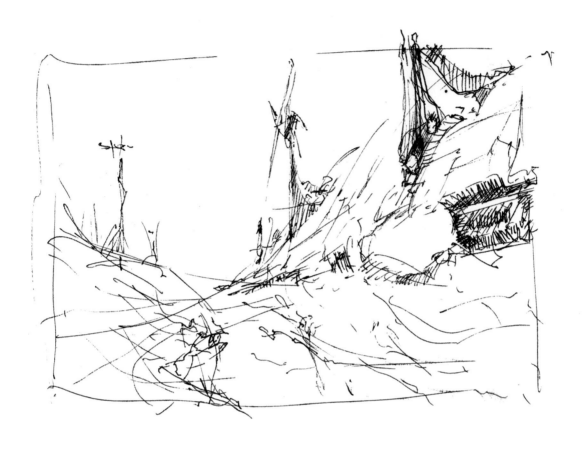

March 2022

"Resources were not readily available for the influx of Z immigrants. Their size, along with staunch xenophobia, made for a difficult fusion. The hundreds of vessels shipwrecked along the coast were cabled together to form makeshift project housing. At the advent, much of the Z population flourished alongside the once-populated fishing and farming communities of western Ireland."

excerpt from:
Monument, A Survey of the Terran Landscape

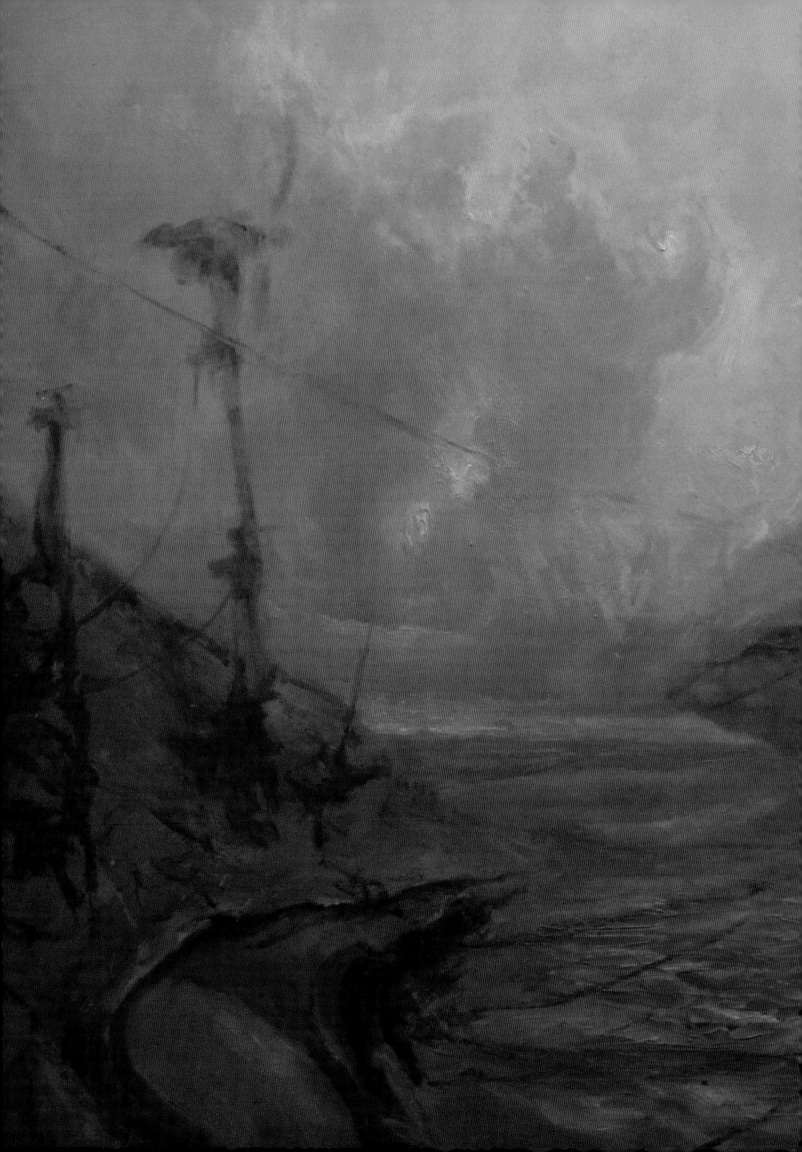

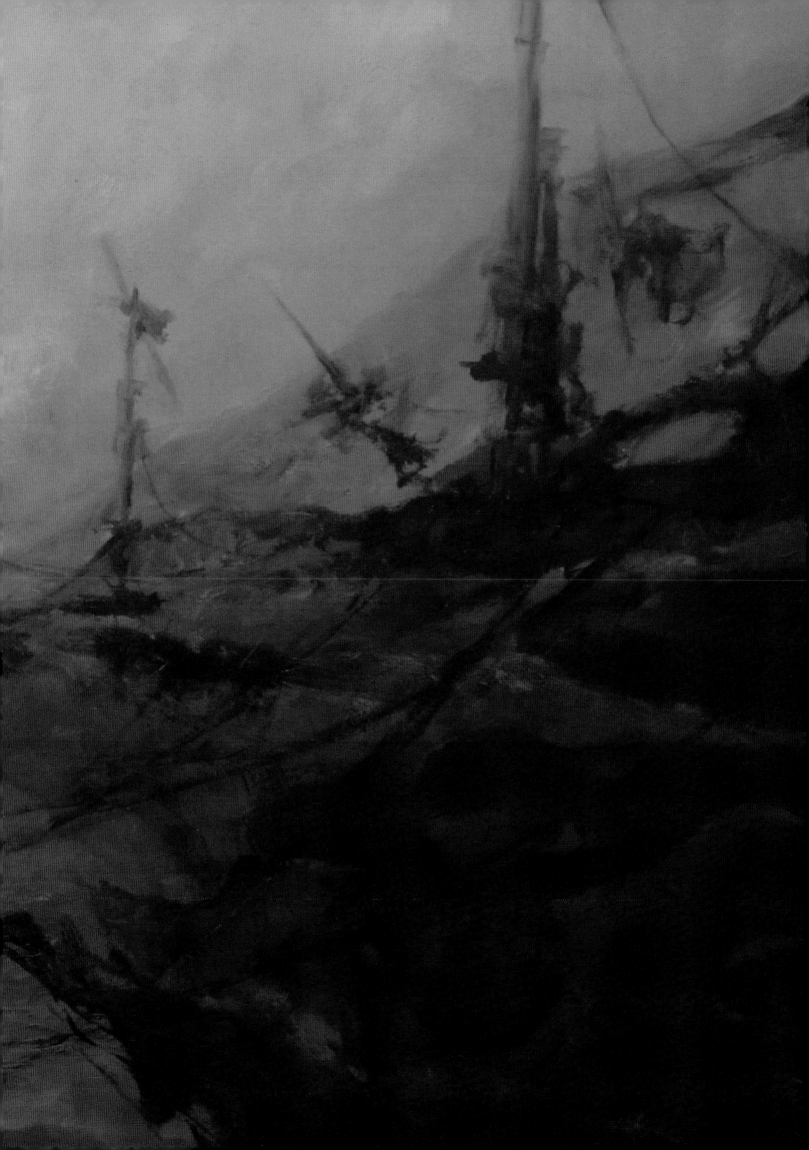

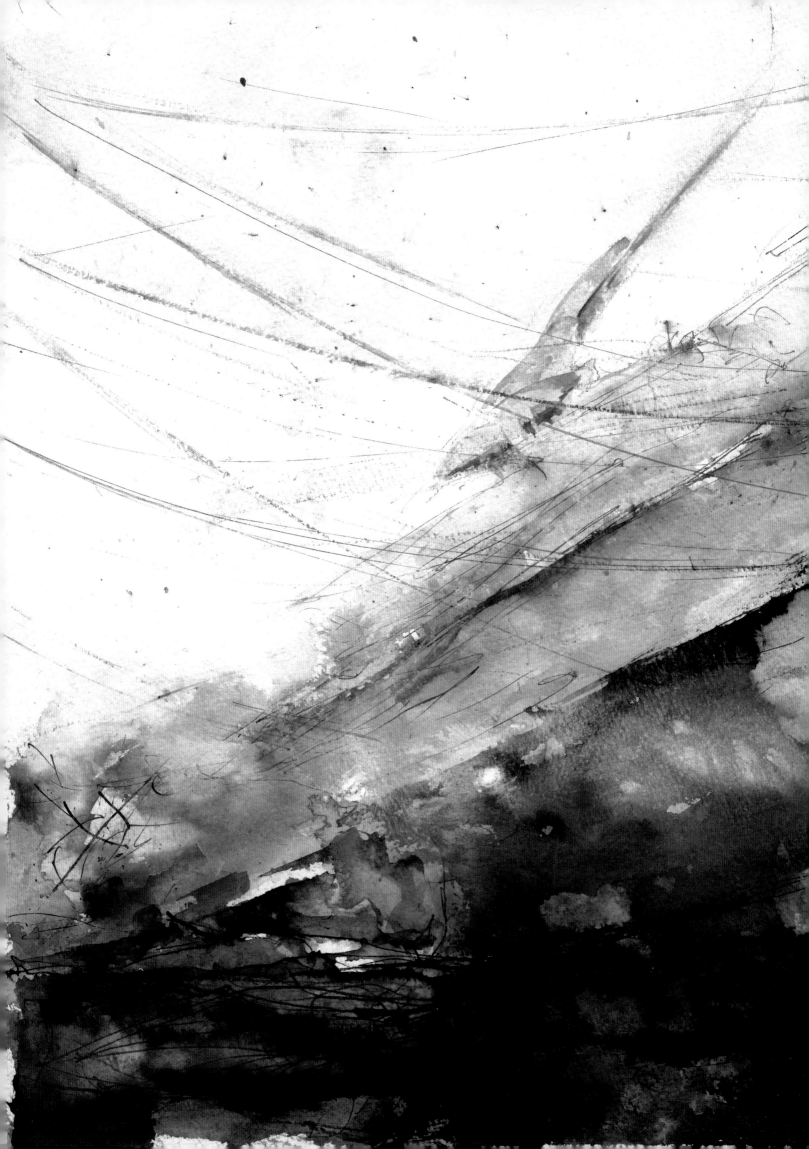

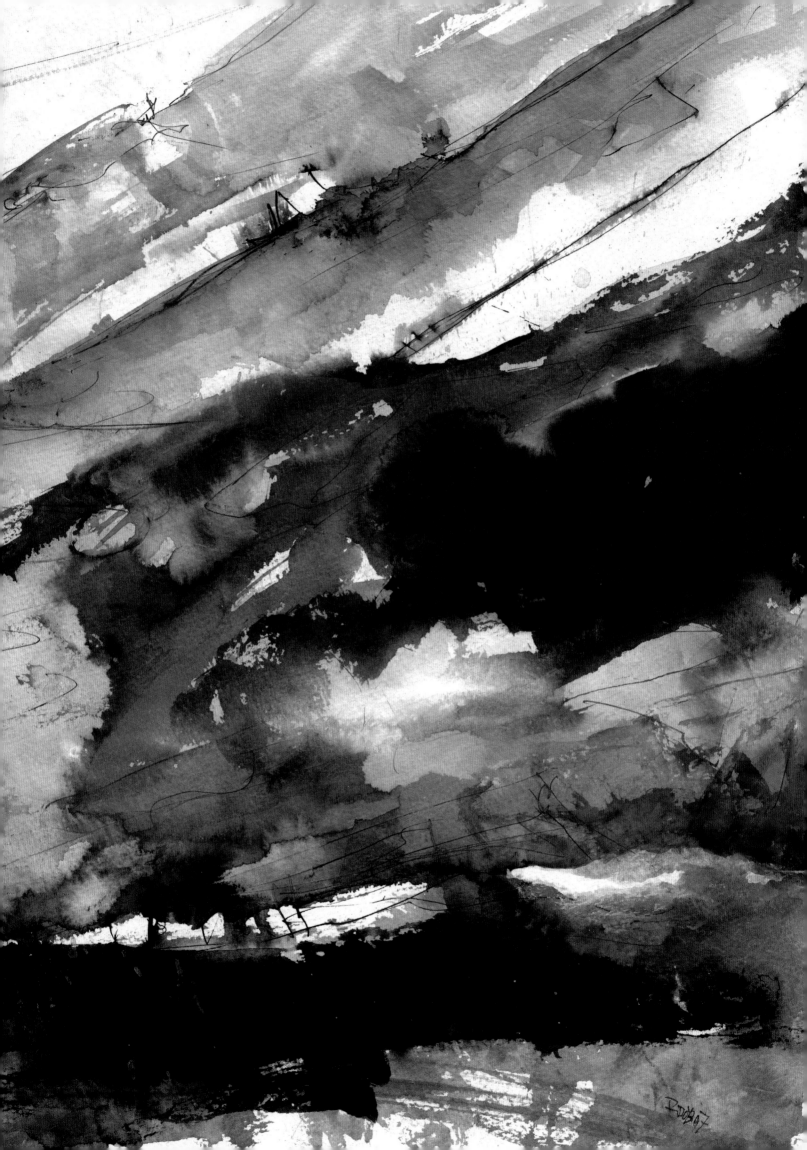

Times Anchor

Childhood
Sunlight and bee stings
Before vanity and knowing love
Algae under my feet and through my toes

Gravity
Tall grass and wet denim
Treading in a great pulse
Awareness of clothing in water
Of fear
Of doing something wrong
An inappropriate time to discover and learn

Counterweight - Rick O'Brien

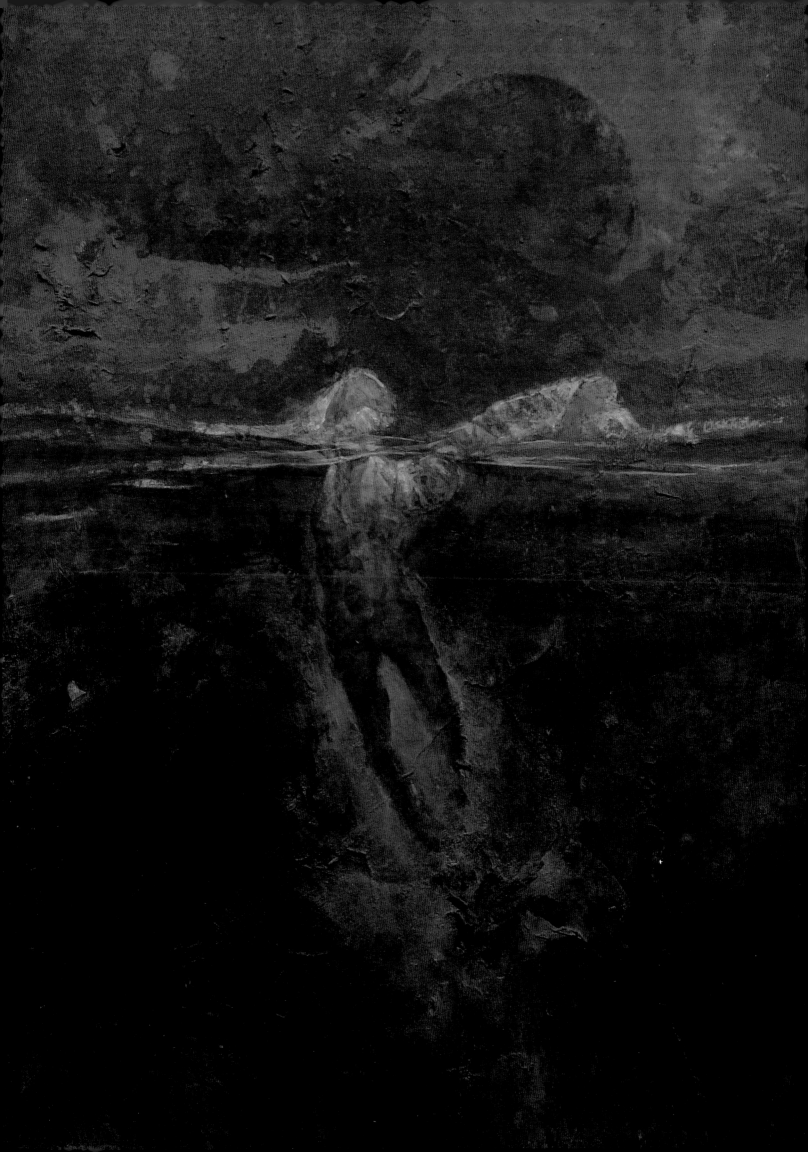

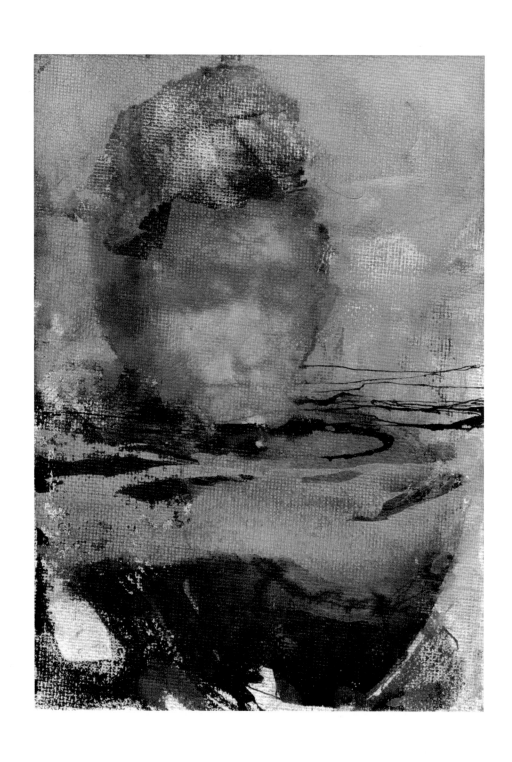

Counterweight - Rick O'Brien

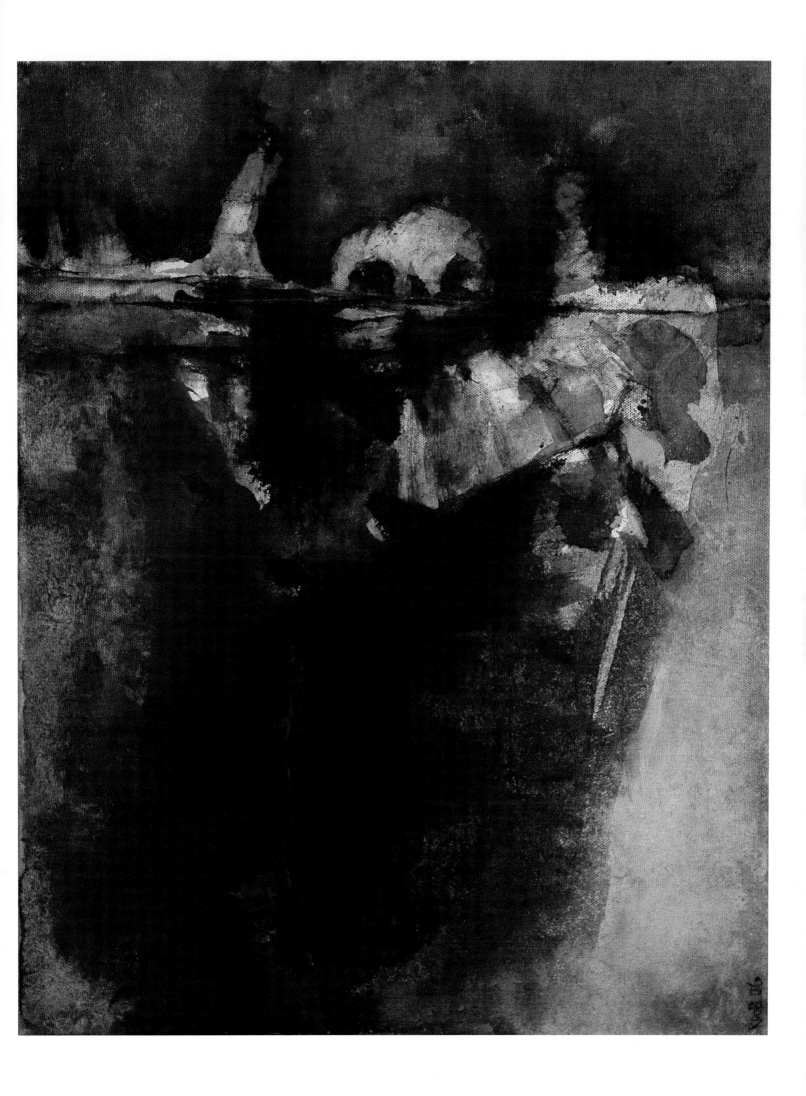

Counterweight - Rick O'Brien

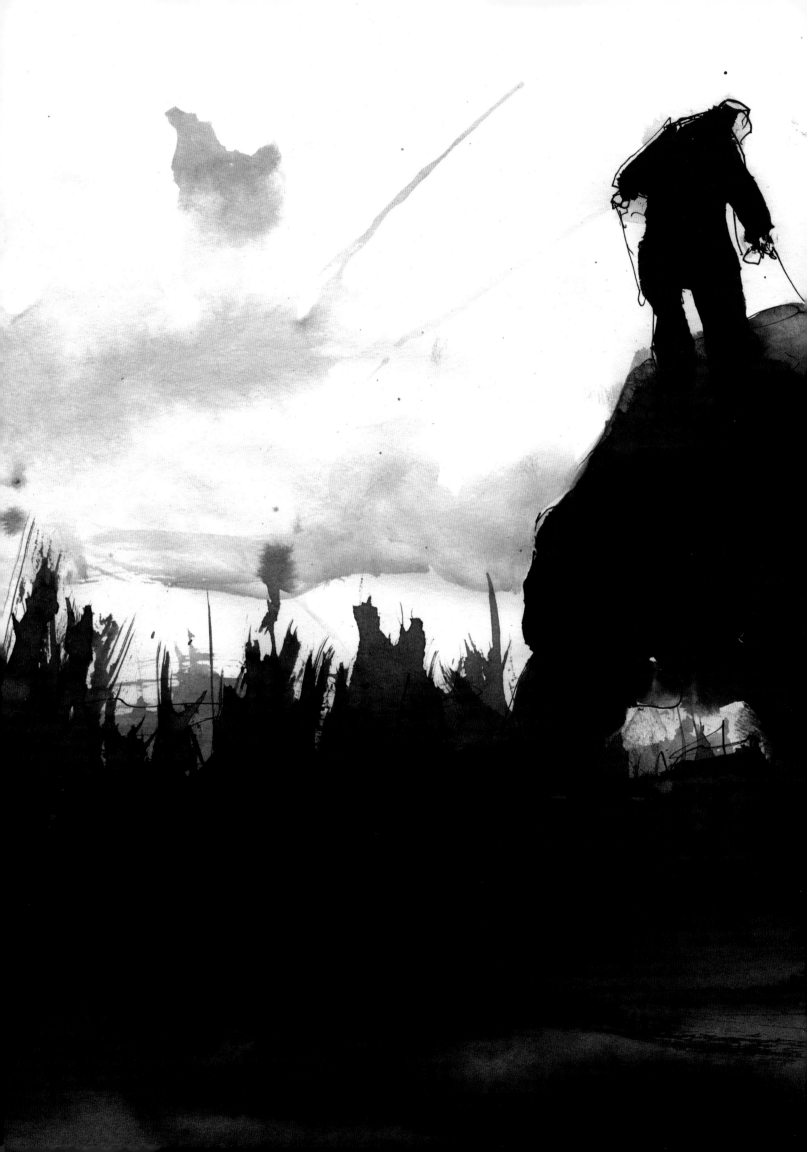

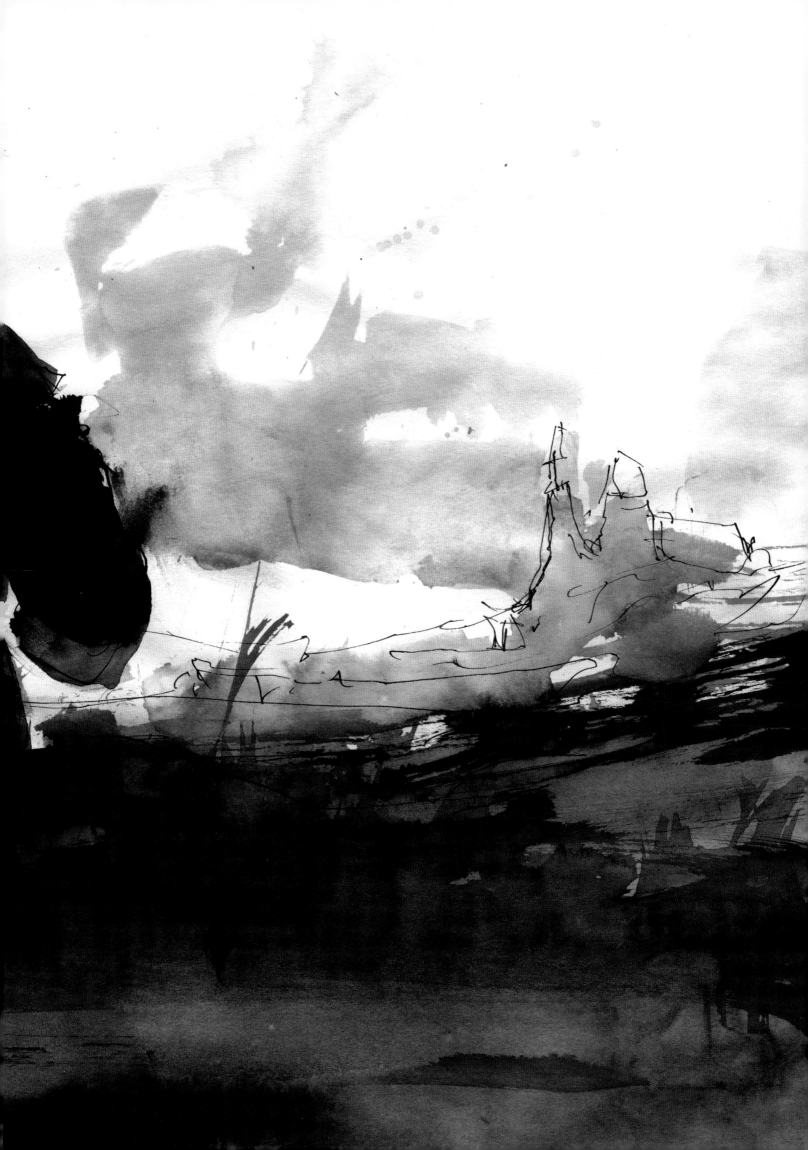

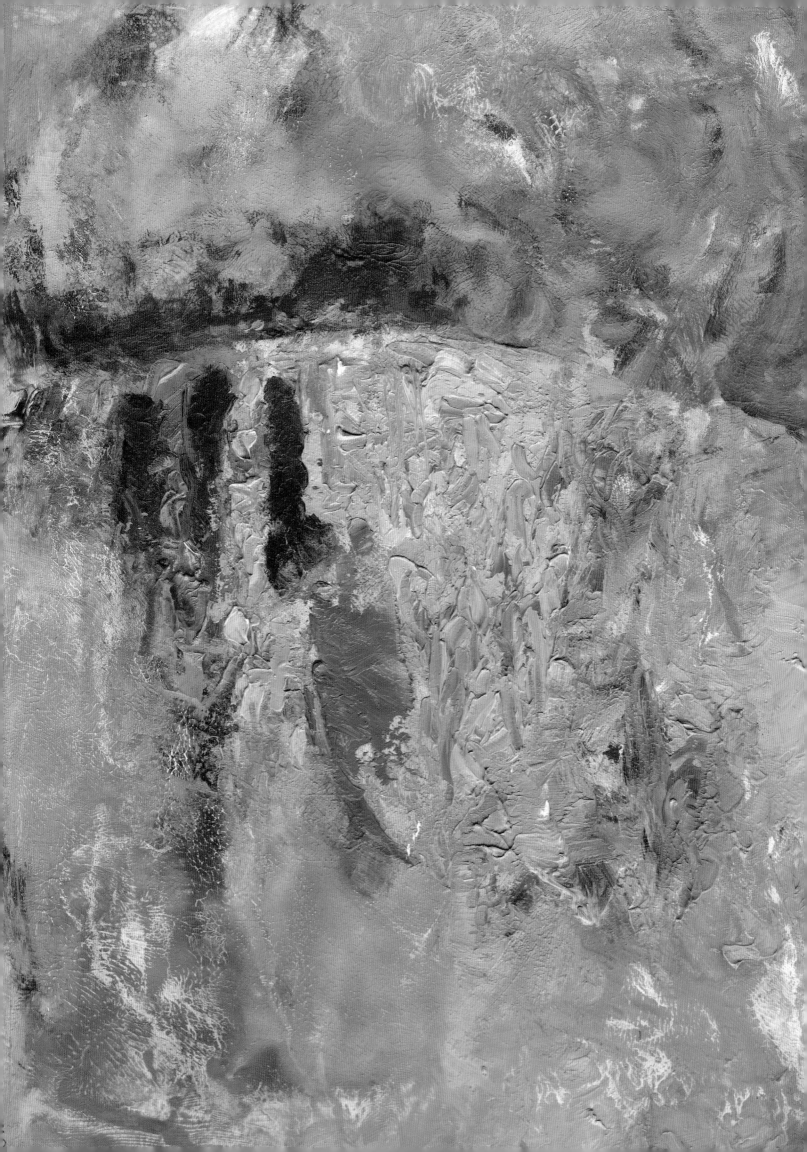

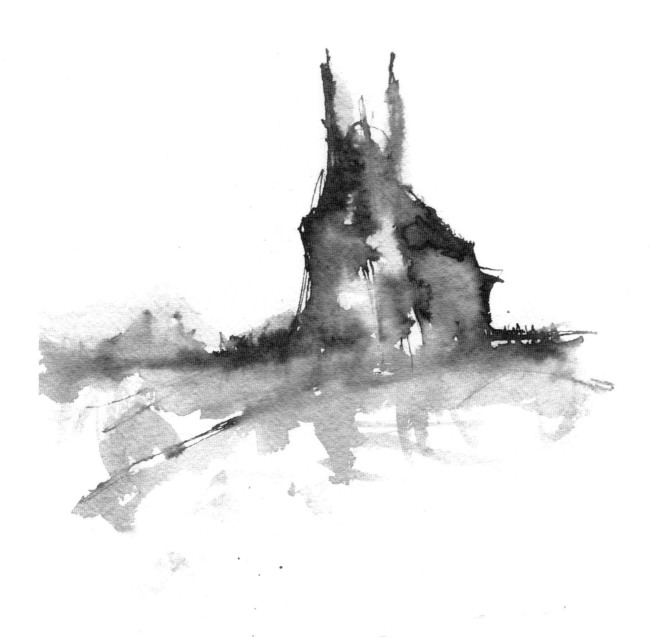

Counterweight - Rick O'Brien

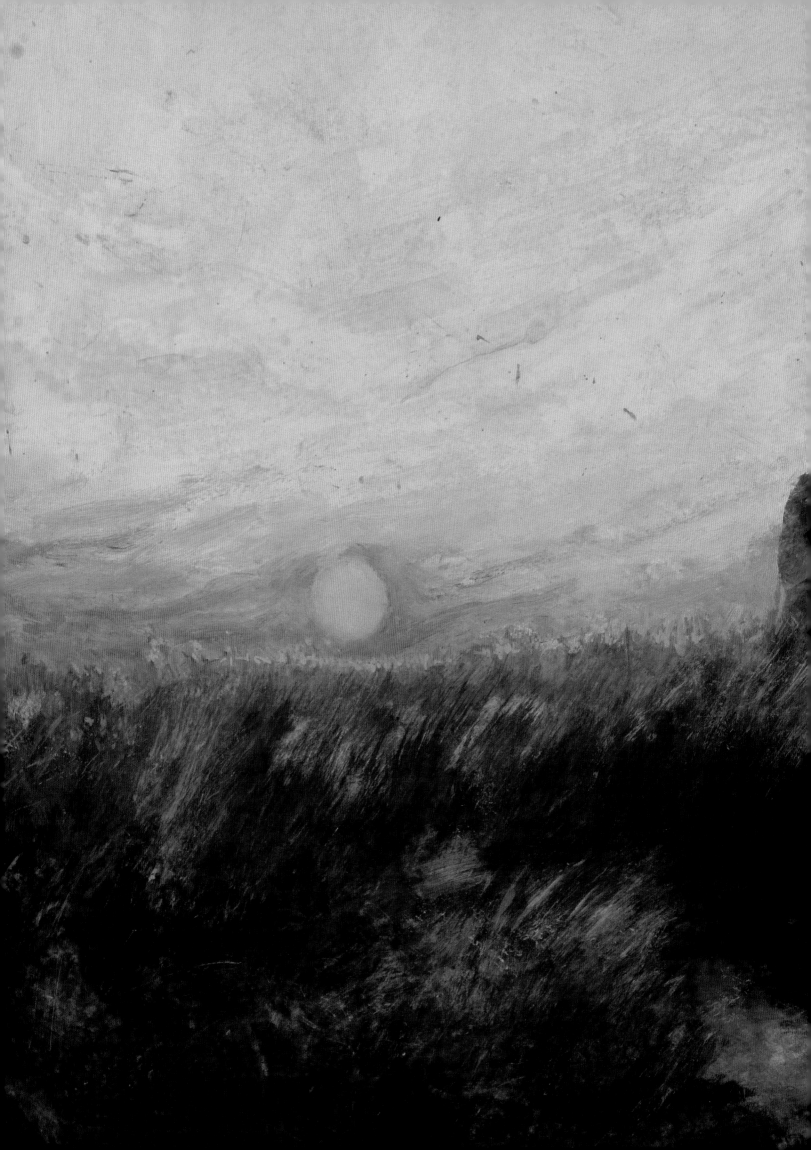

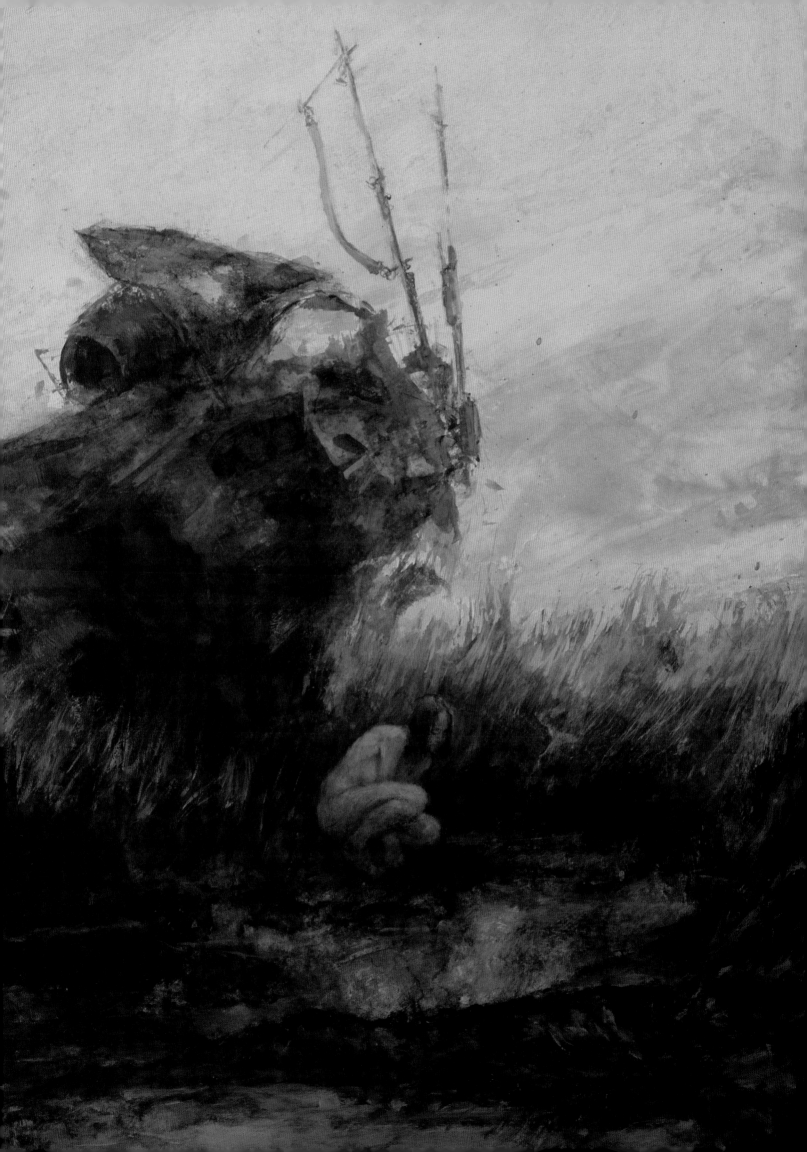

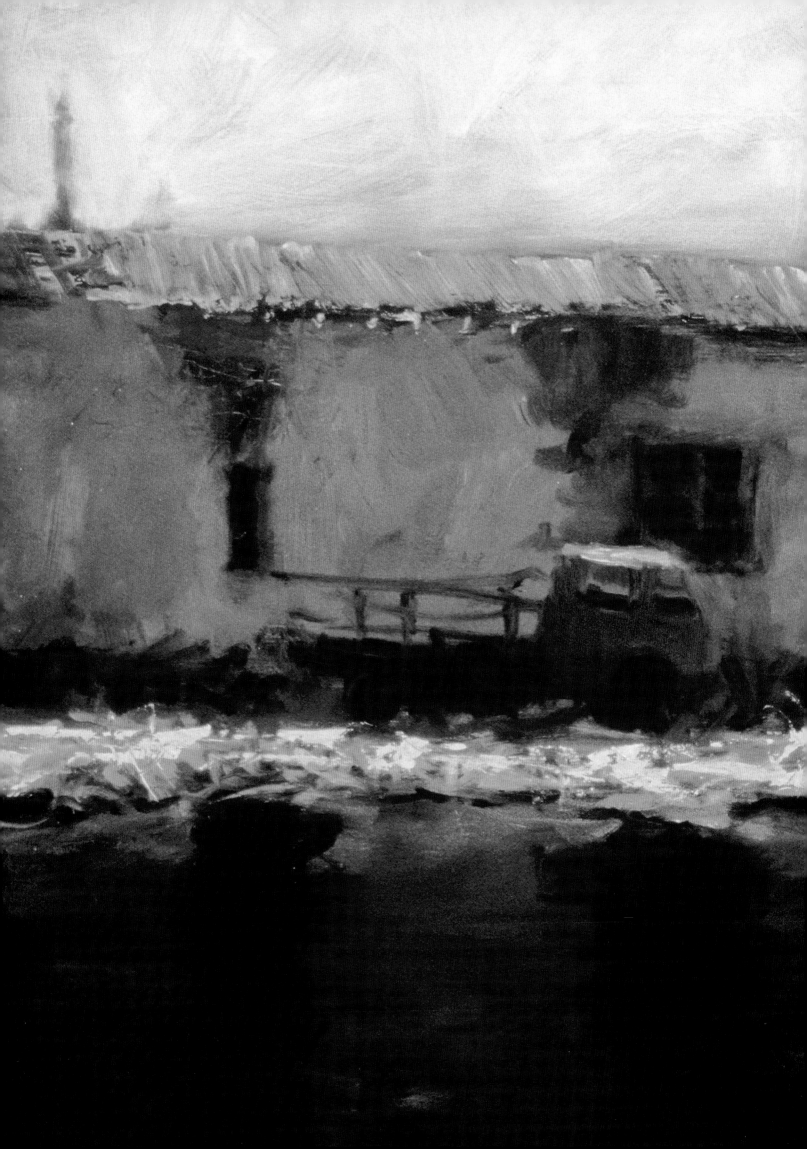

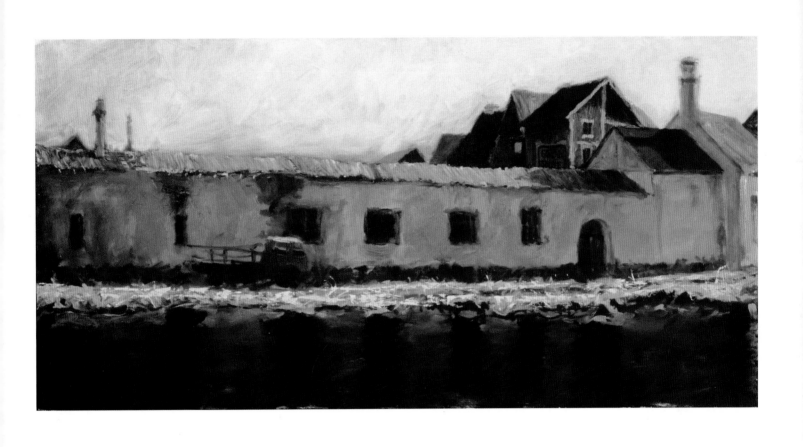

Counterweight - Rick O'Brien

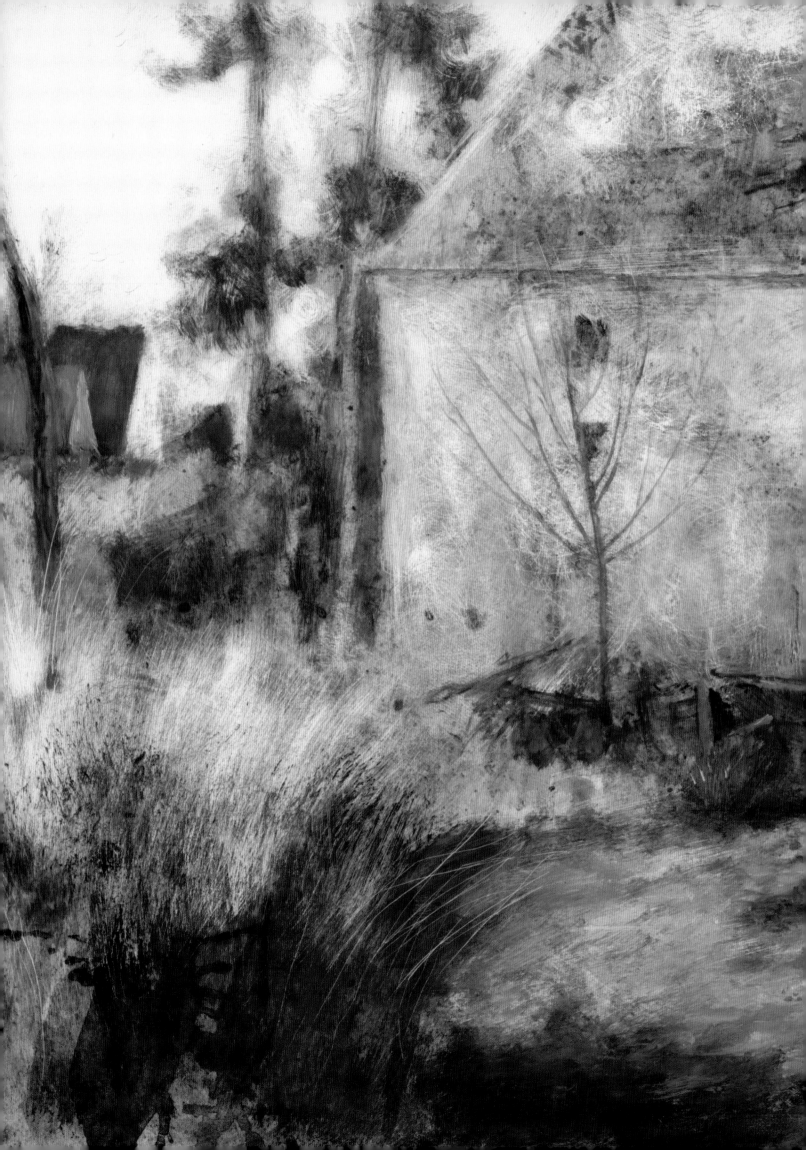

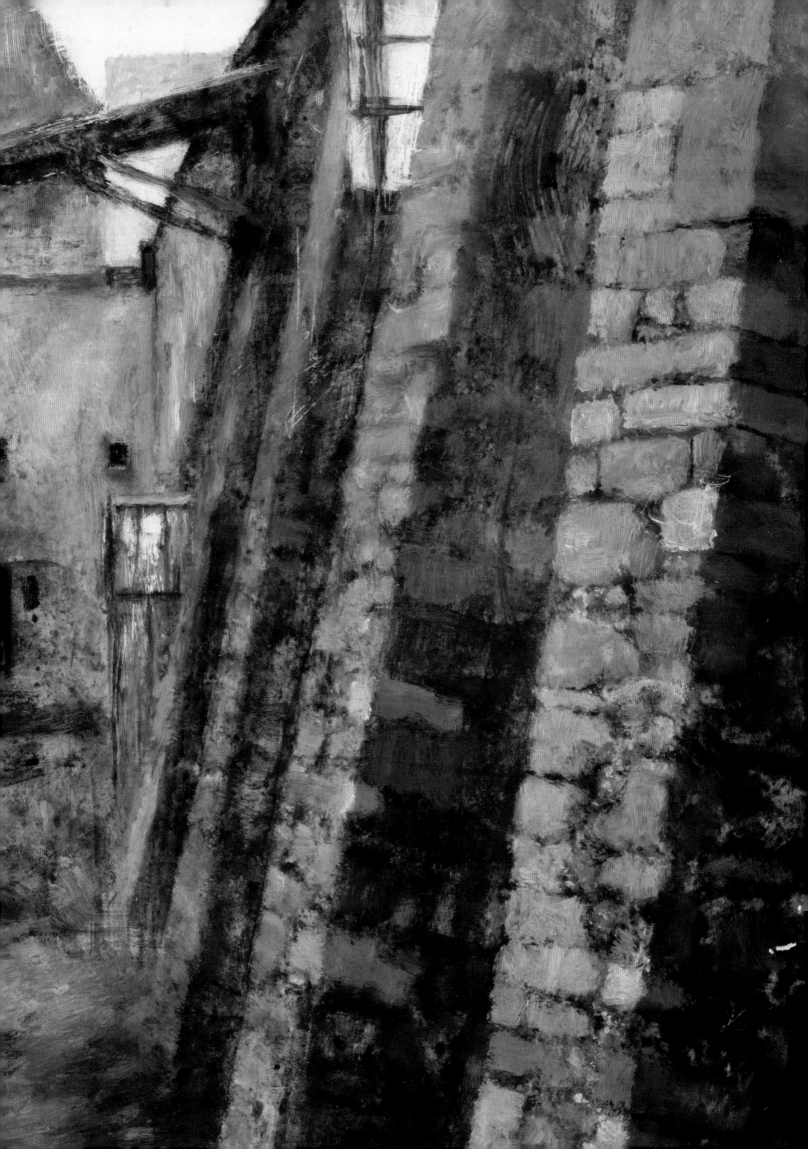

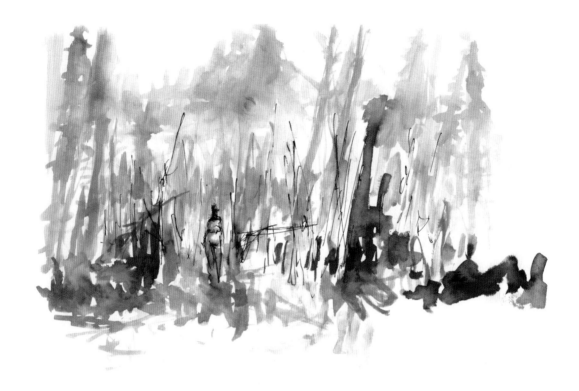

Popovice, or *The Language Barrier*

Lost.

Ignorance of geography
And the moonlit Czech landscape.
Cold war nostalgia….
Was that a bear?!
Fear and discovery
Cheap beer in a dirty glass
Good company
Tobacco and goulash.

Hope.

Charades with the bus driver
Glowing red lights in the dense fog
A faint chime
Wolves in the peripheral.

A narrow escape.

Counterweight - Rick O'Brien

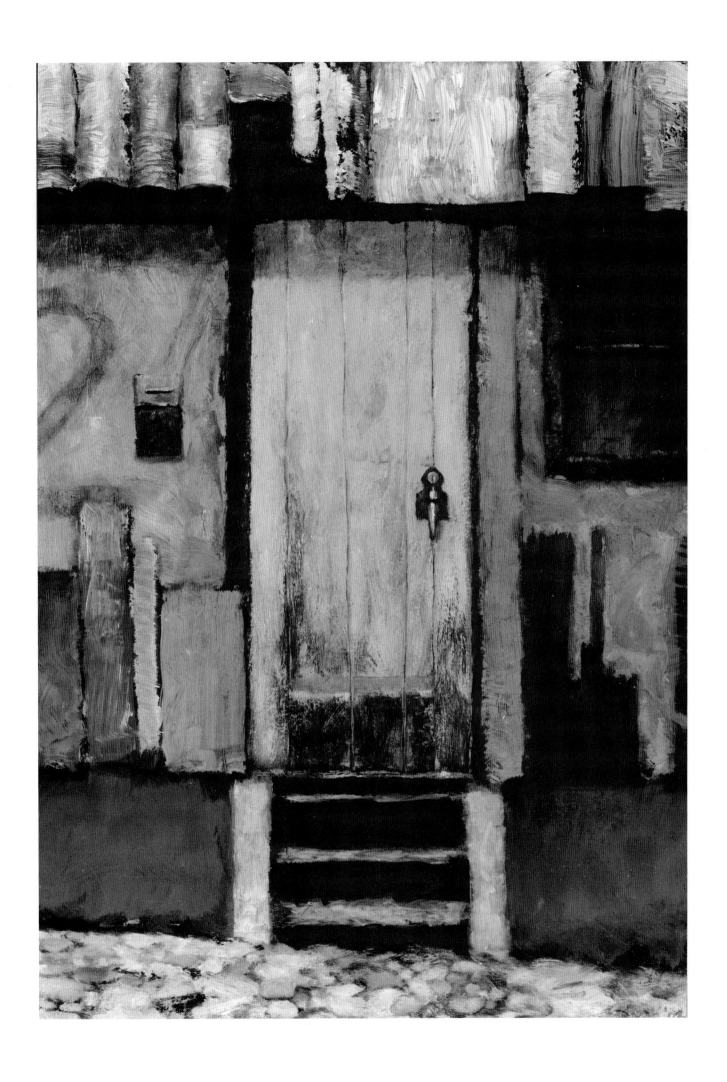

Counterweight - Rick O'Brien

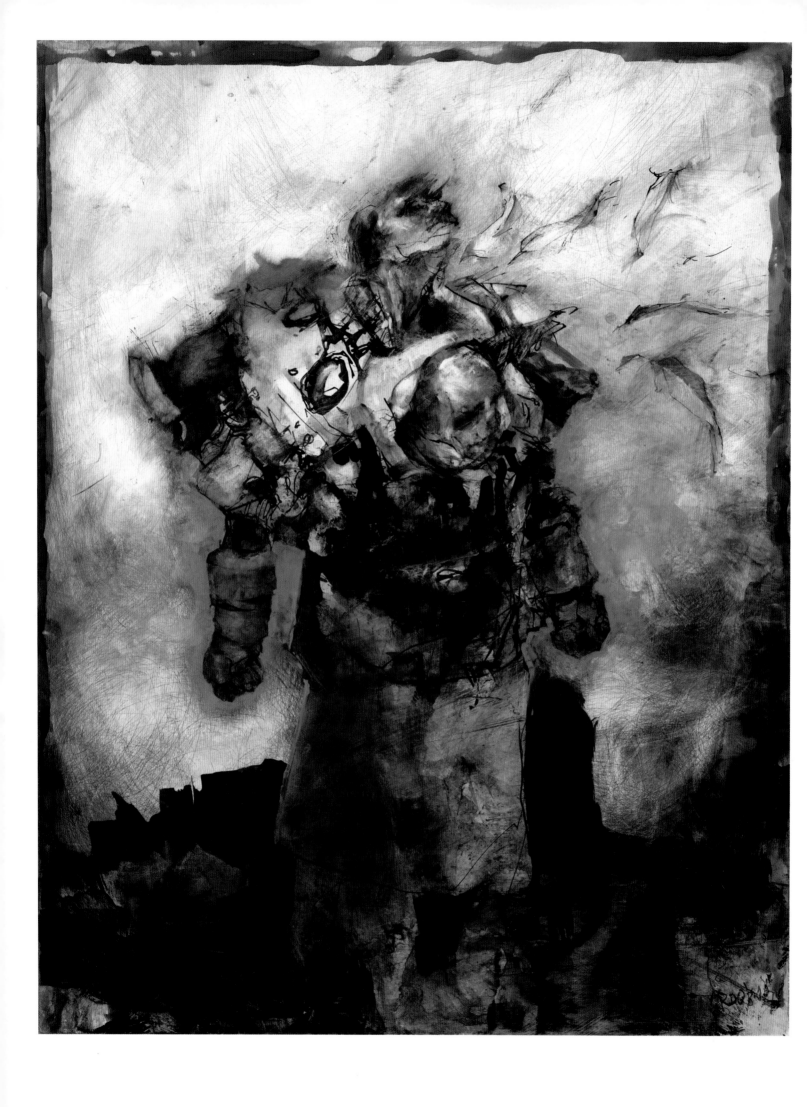

Counterweight - Rick O'Brien

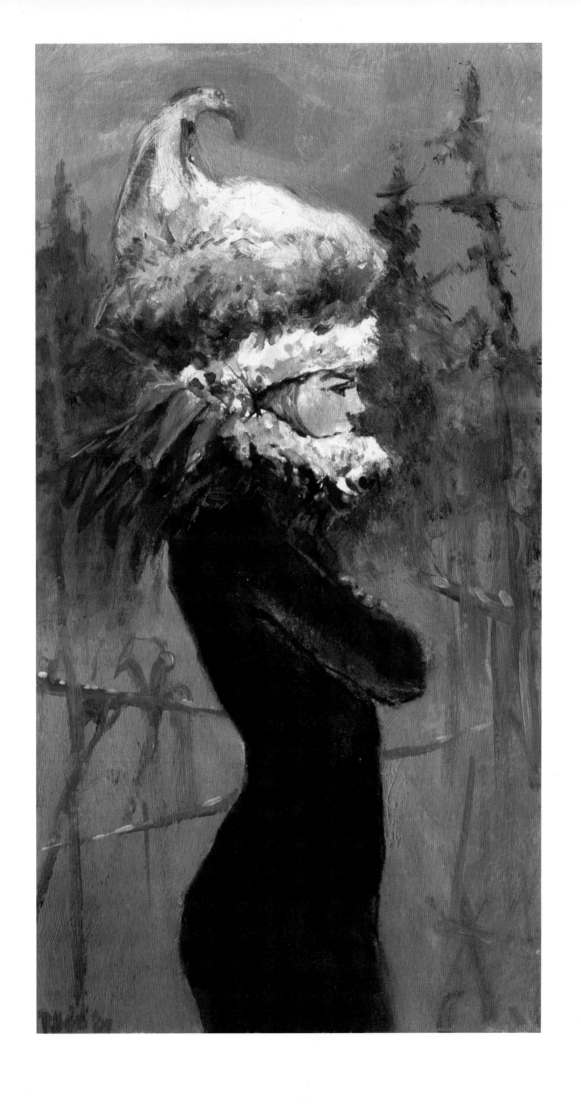

Counterweight - Rick O'Brian

095

Amsterdam

Late Morning. Herded into an overcrowded tram I found myself securely anchored to a window seat. The conductor managed the congested tracks defiantly. Suddenly, the manic commute was interrupted by a jarring lunge forward. Traffic? Perhaps a downed pedestrian? The tram crept and the world grew silent. My peripheral spied a stilted figure lumbering through a narrow and abandoned alleyway. At that moment nothing in my world existed but the perceived contact between my senses and the stare of the awkward but somehow elegant form which the city quickly absorbed. The tram heaved forward and I began to read the faces of my fellow cattle. Though language was an obstacle, it was plain to see the encounter was a personal one.

Counterweight - Rick O'Brien

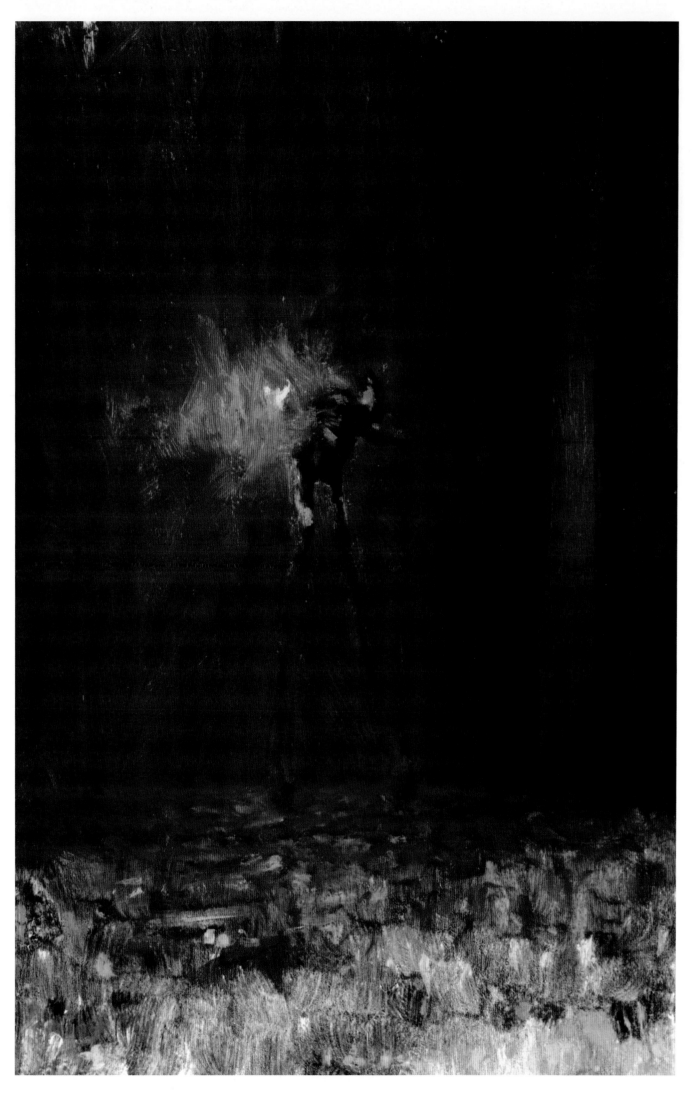

Counterweight - Rick O'Brien

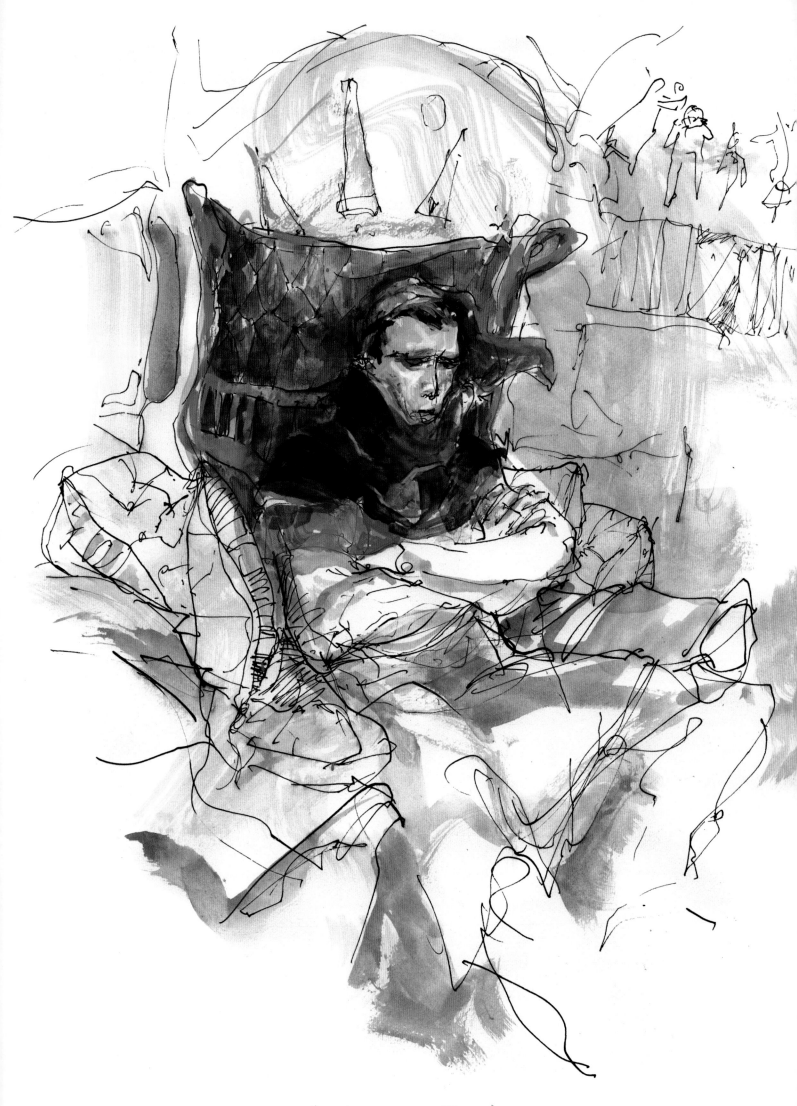

Counterweight · Rick O'Brien

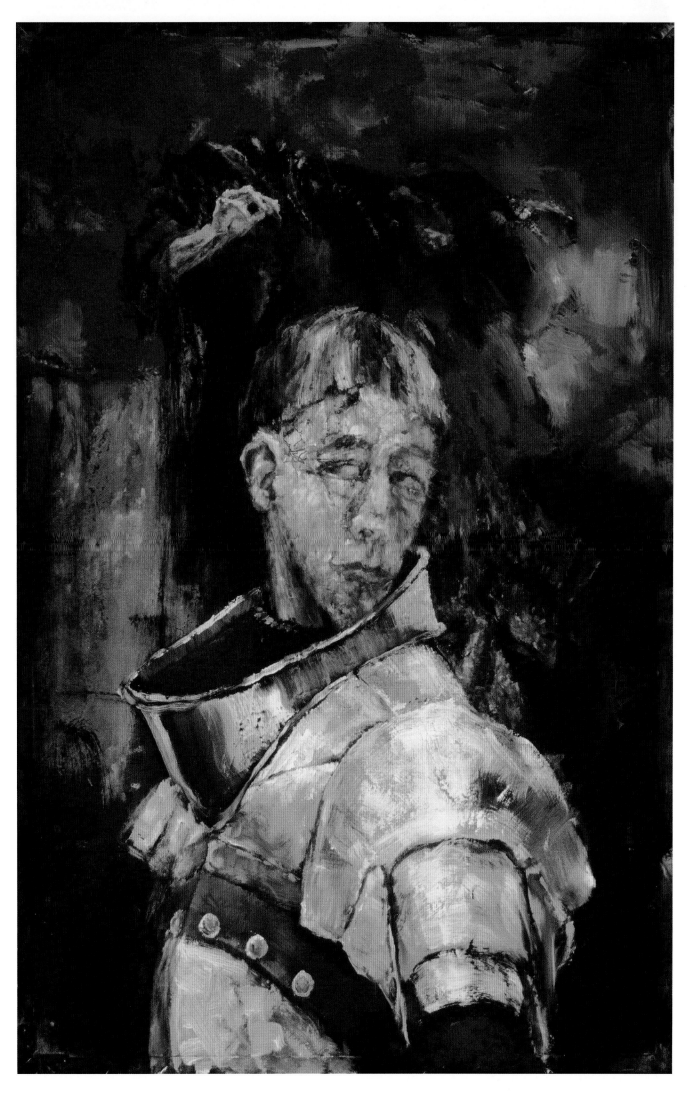

Counterweight - Rick O'Brien

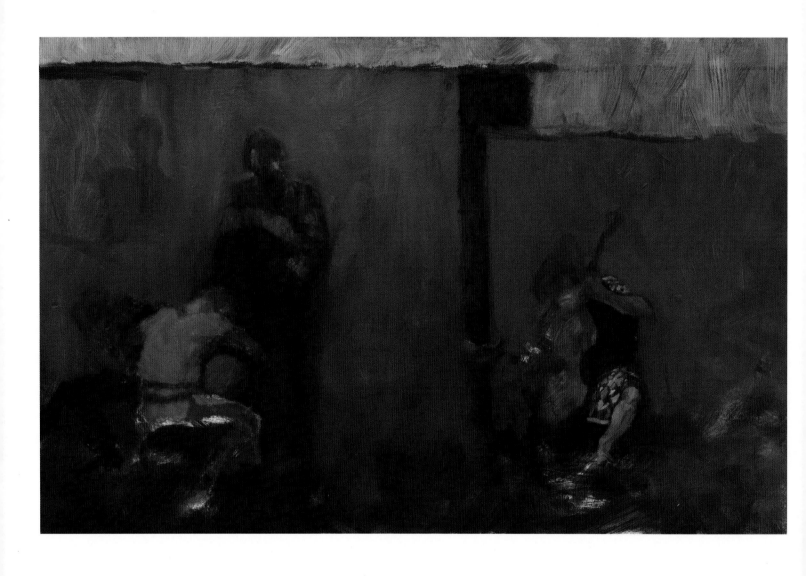

Counterweight - Rick O'Brien

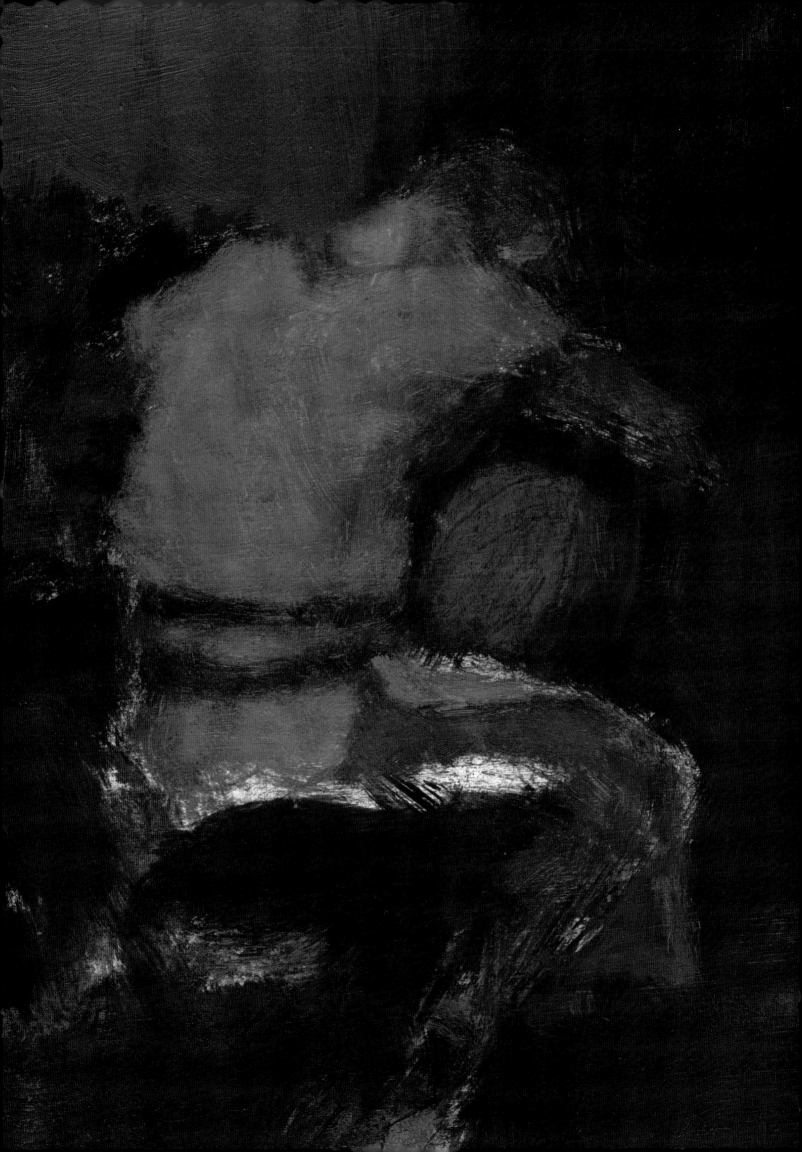

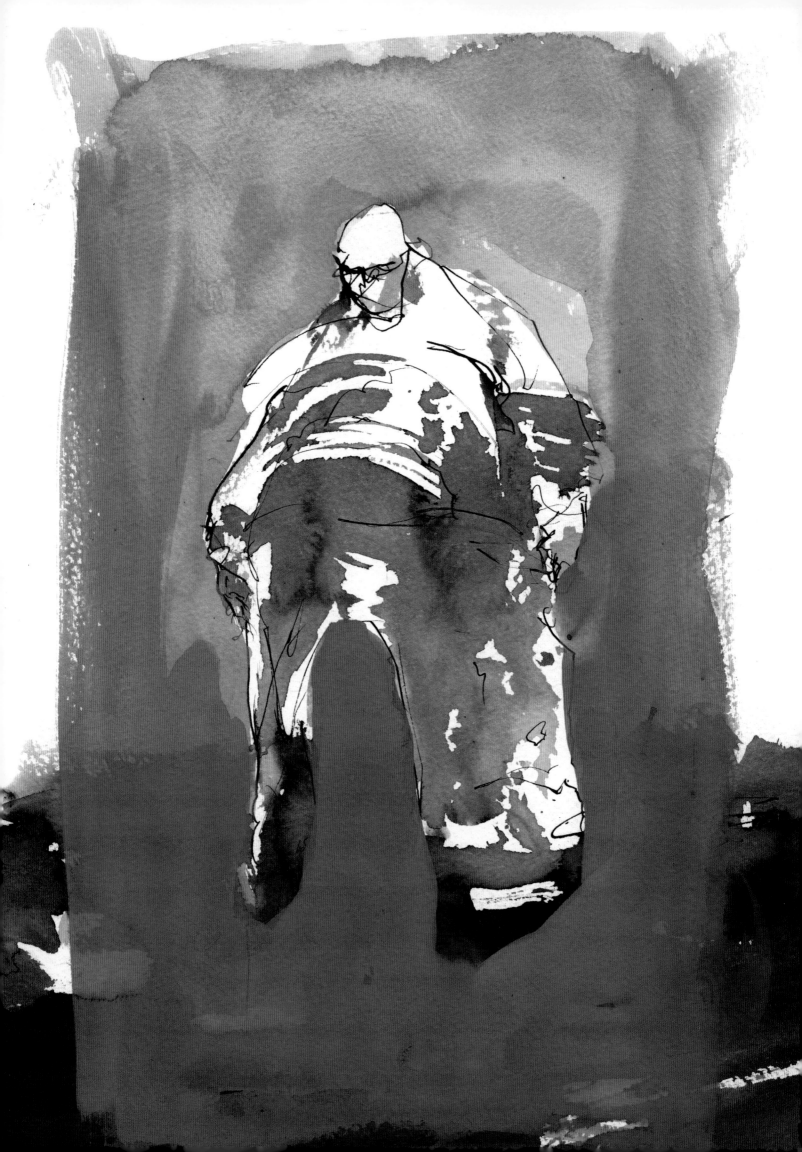

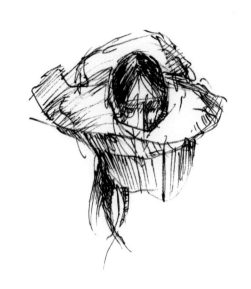

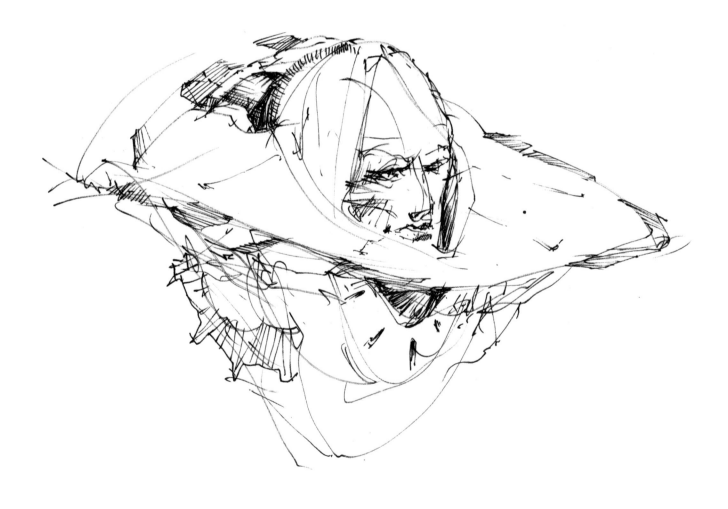

Counterweight - Rick O'Brien

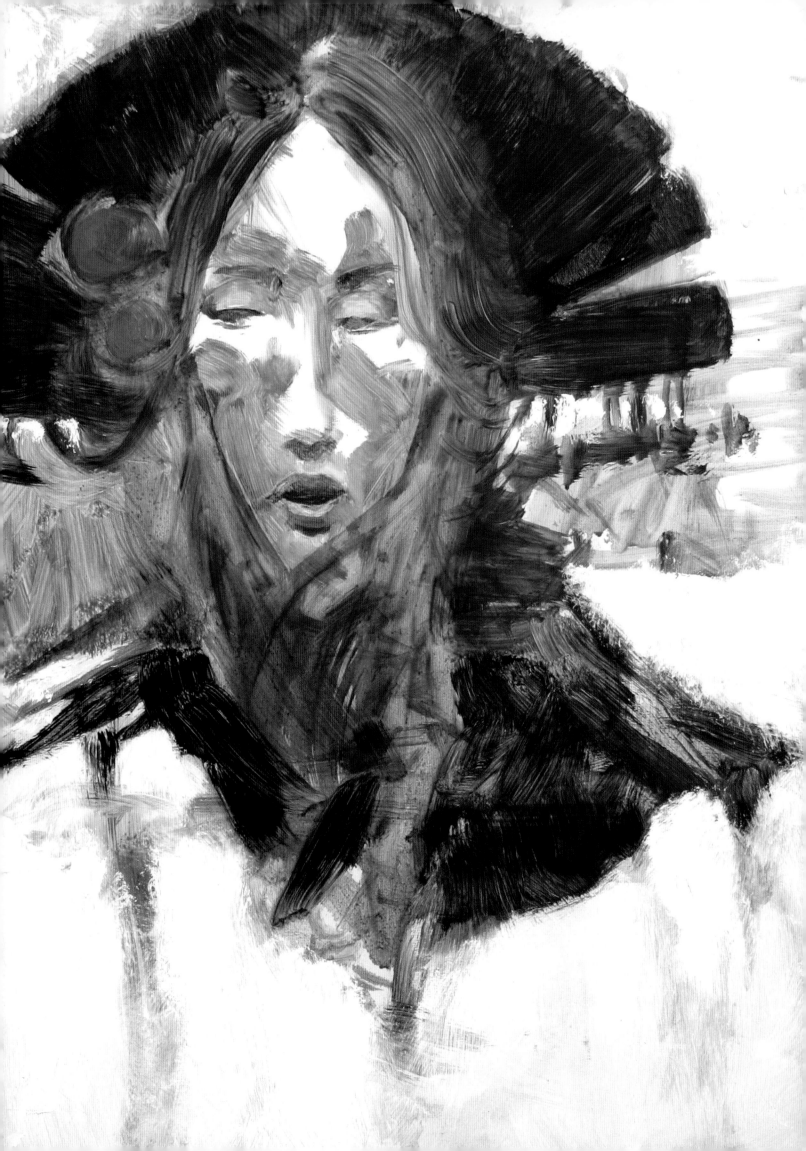

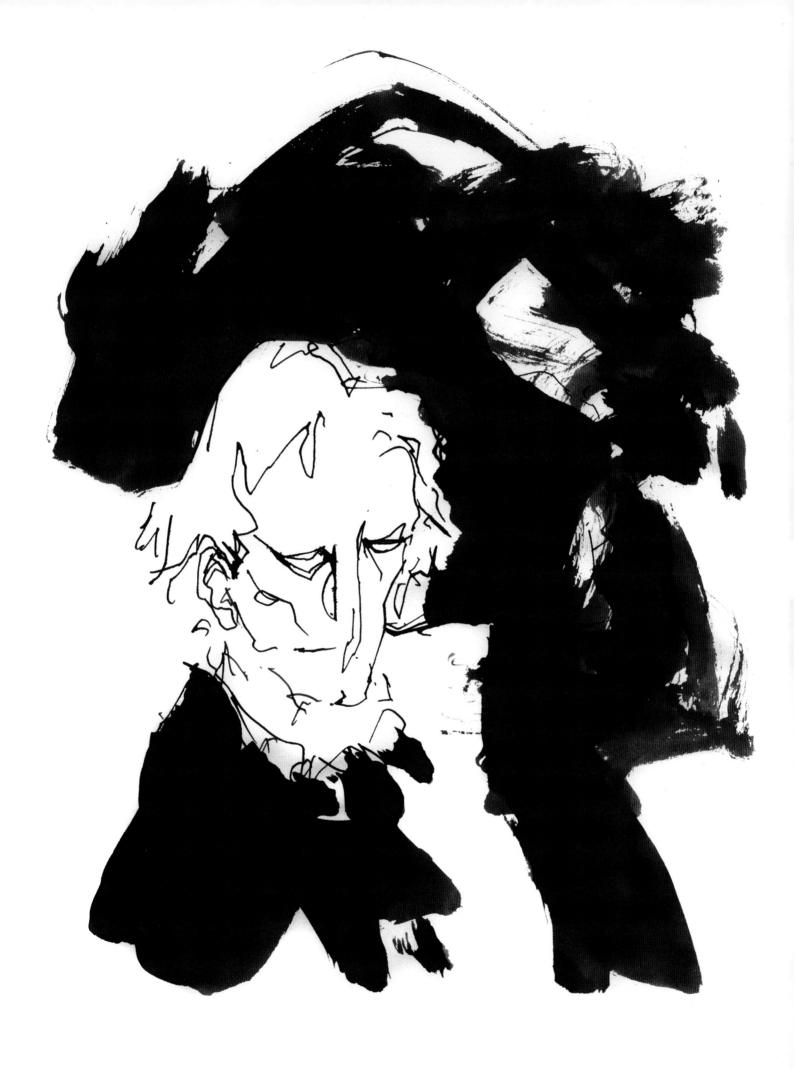

Counterweight - Rick O'Brien

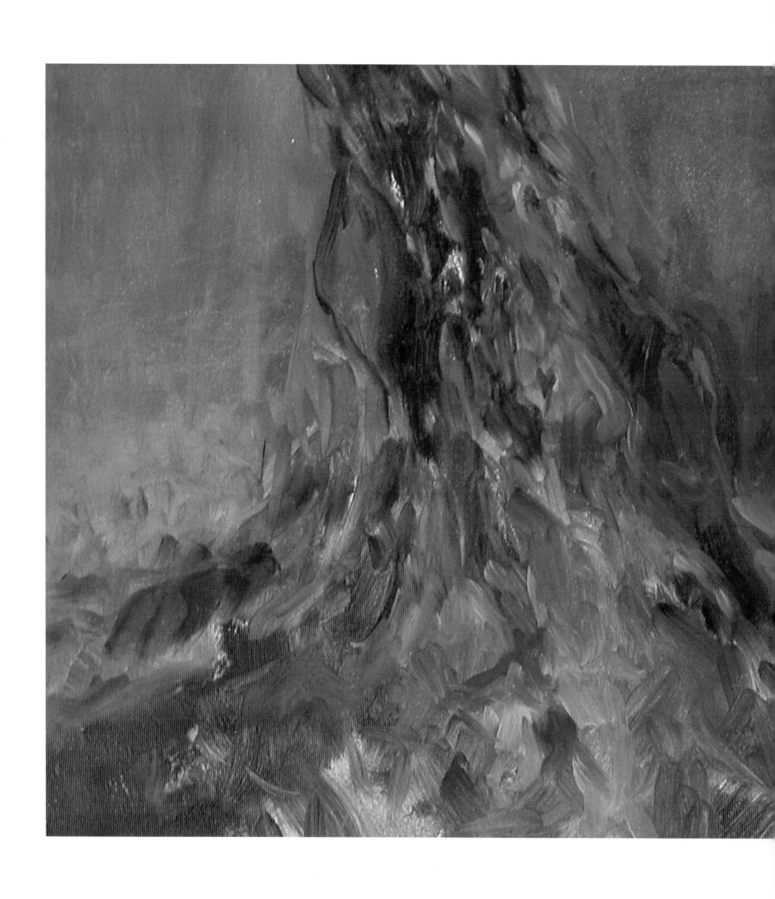

Counterweight - Rick O'Brien

Counterweight - Rick O'Brien

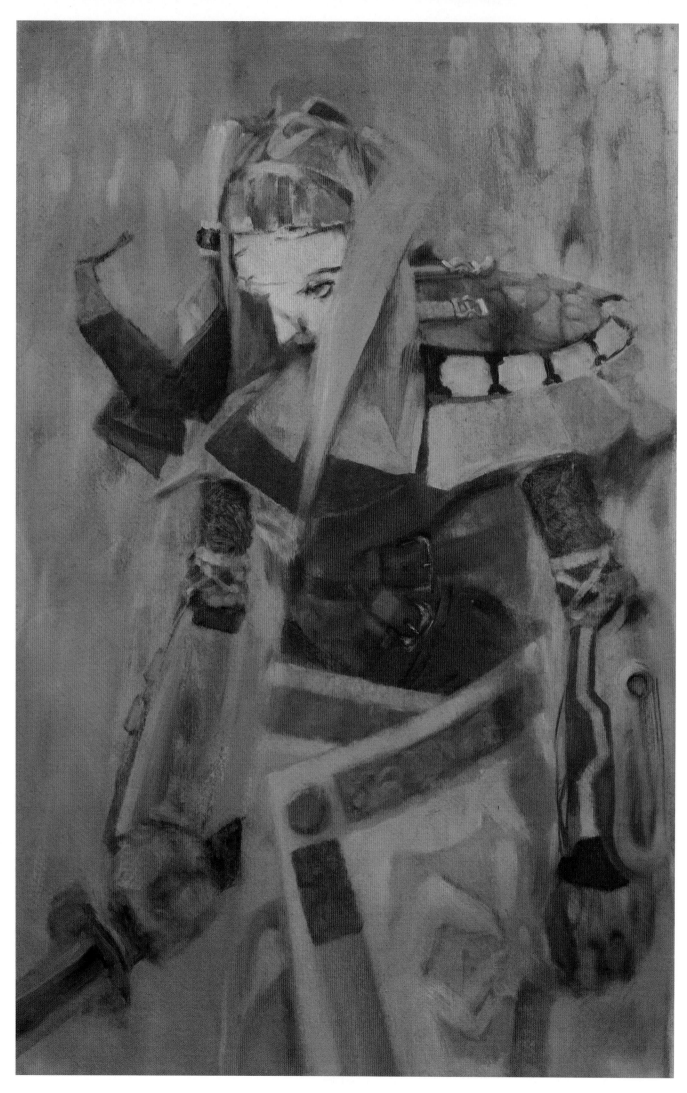

Counterweight - Rick O'Brien

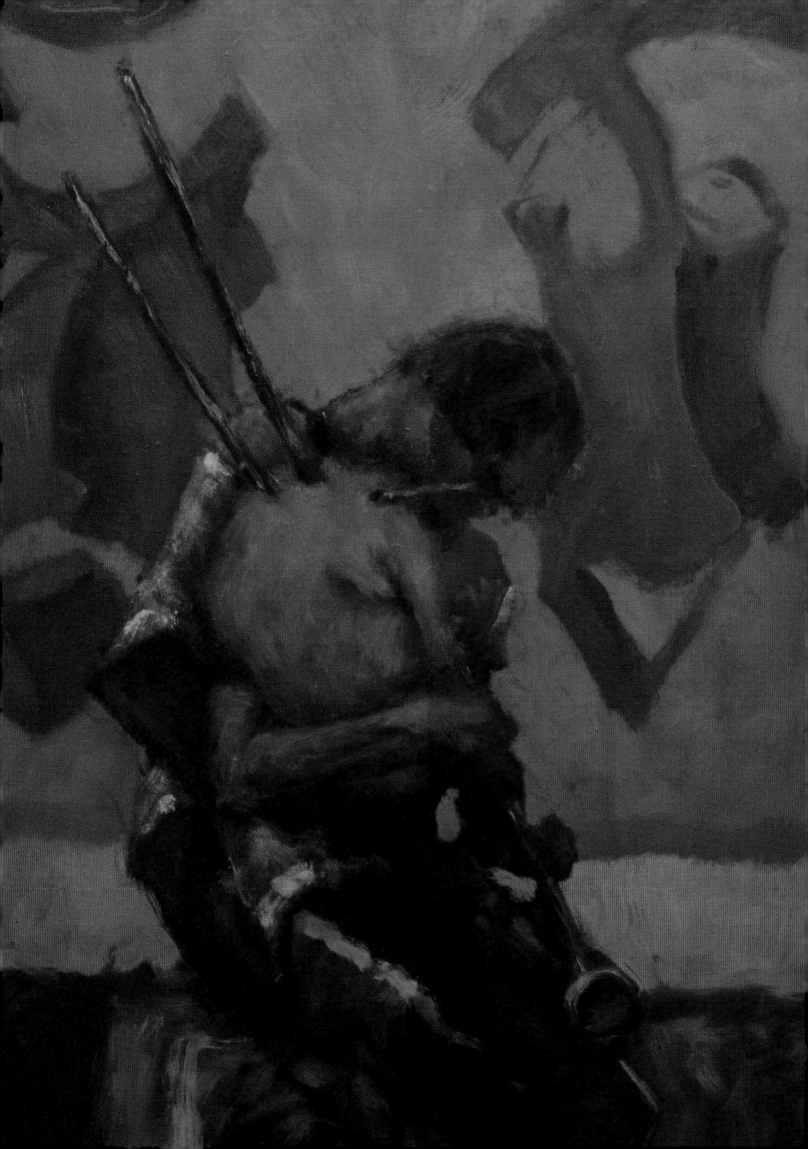

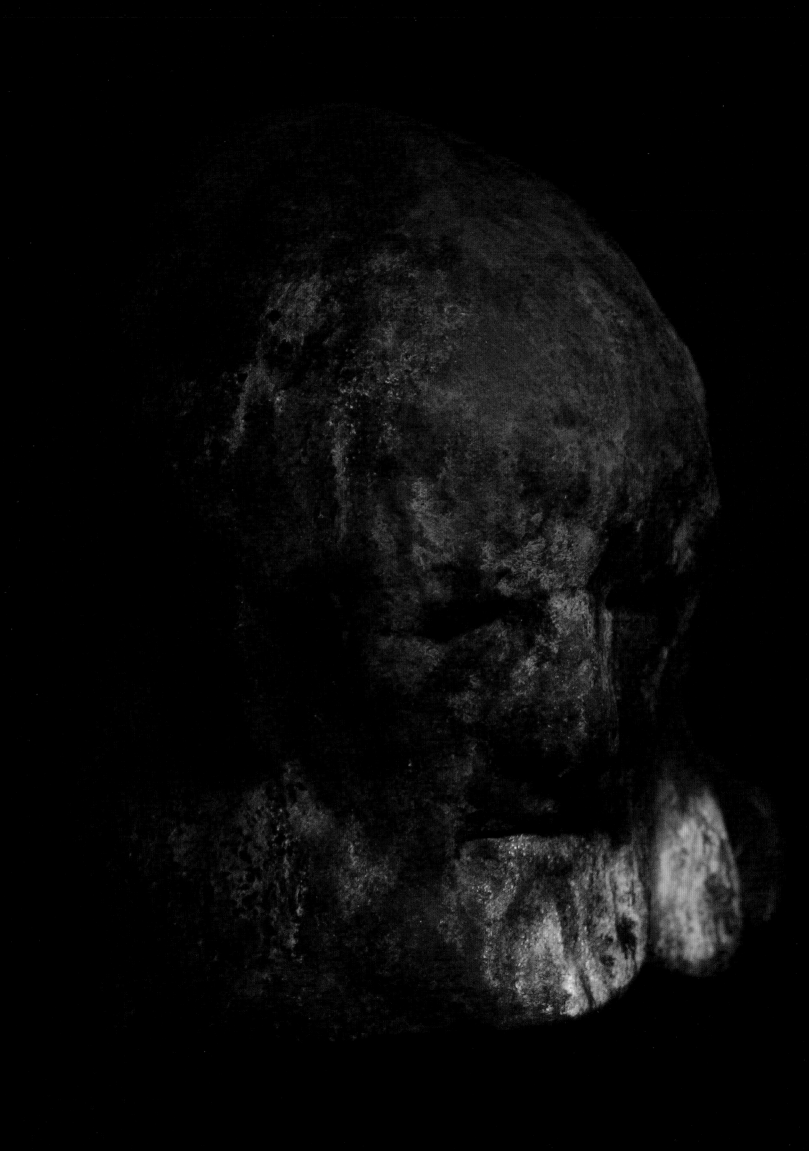

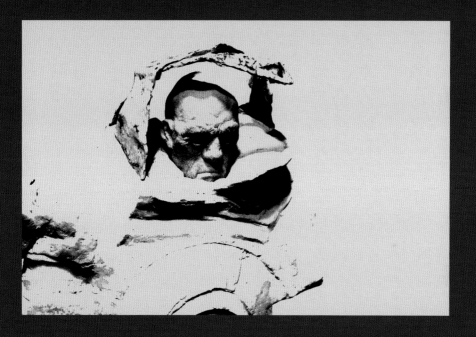

In keeping with the premise that execution remain servant to intent, the following works render previously visited themes through three dimensional mediums. Characters and concepts explored in *The Range of Humanity,* that richly and often blatantly used metaphor and iconography, are chiefly represented over the following pages. The physicality of these ideas is a gratifying and welcome evolution to the creative process.

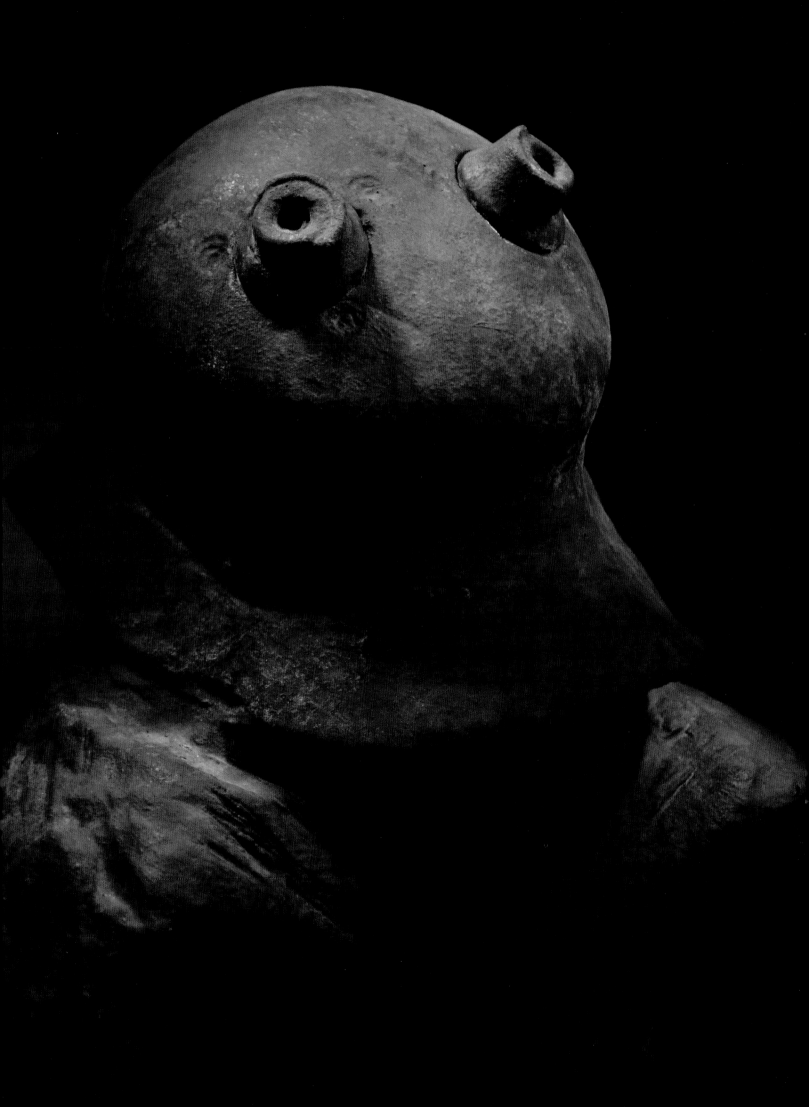

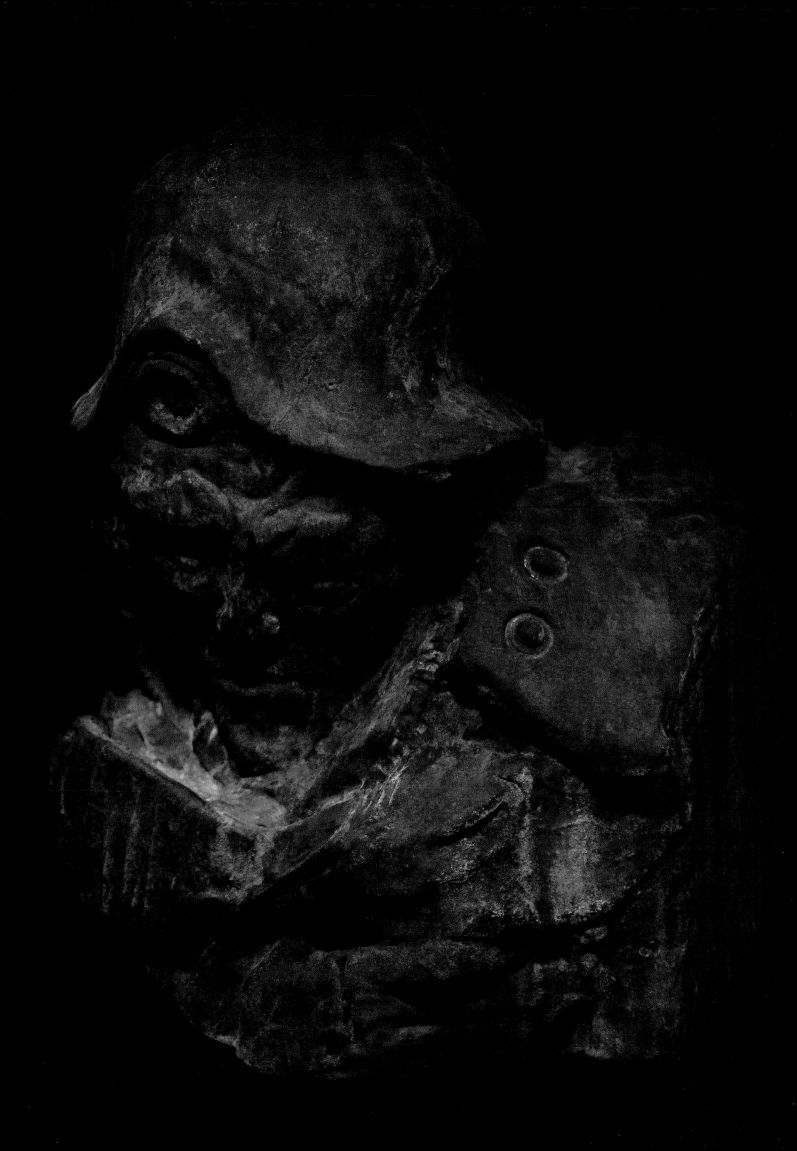

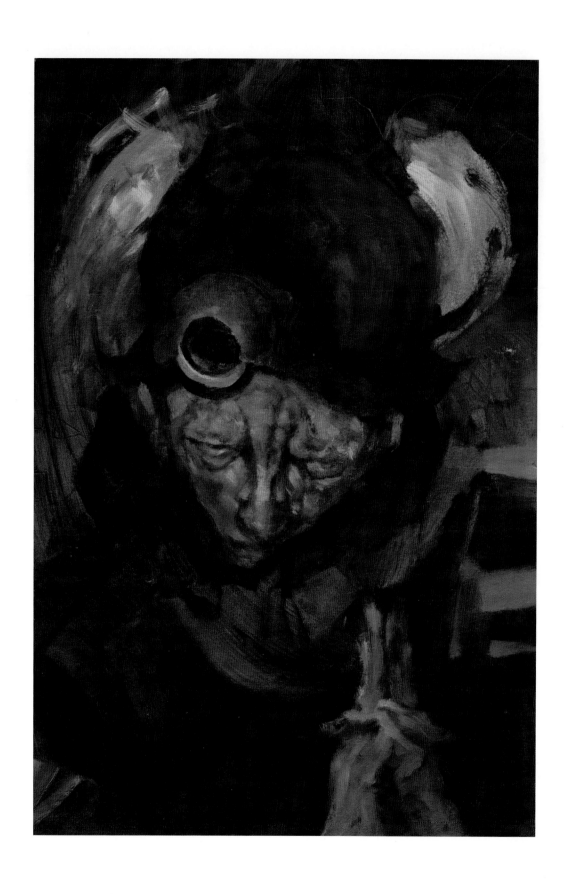

Counterweight - Rick O'Brien

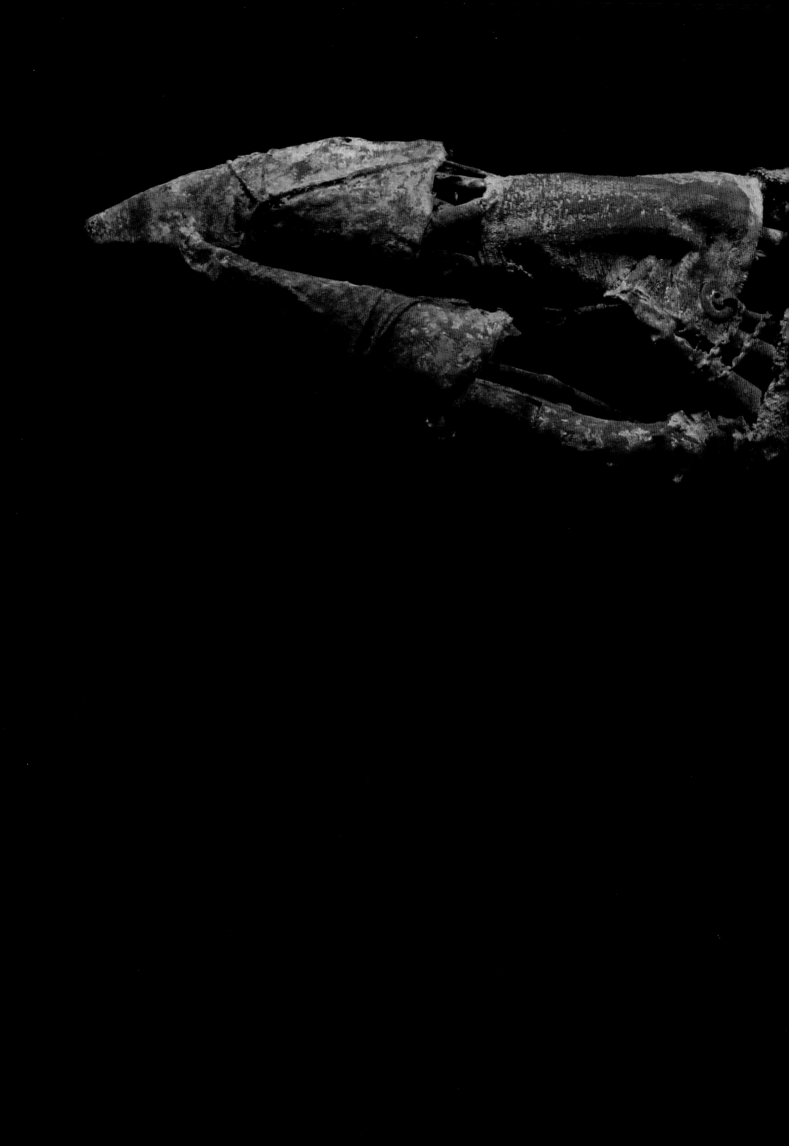

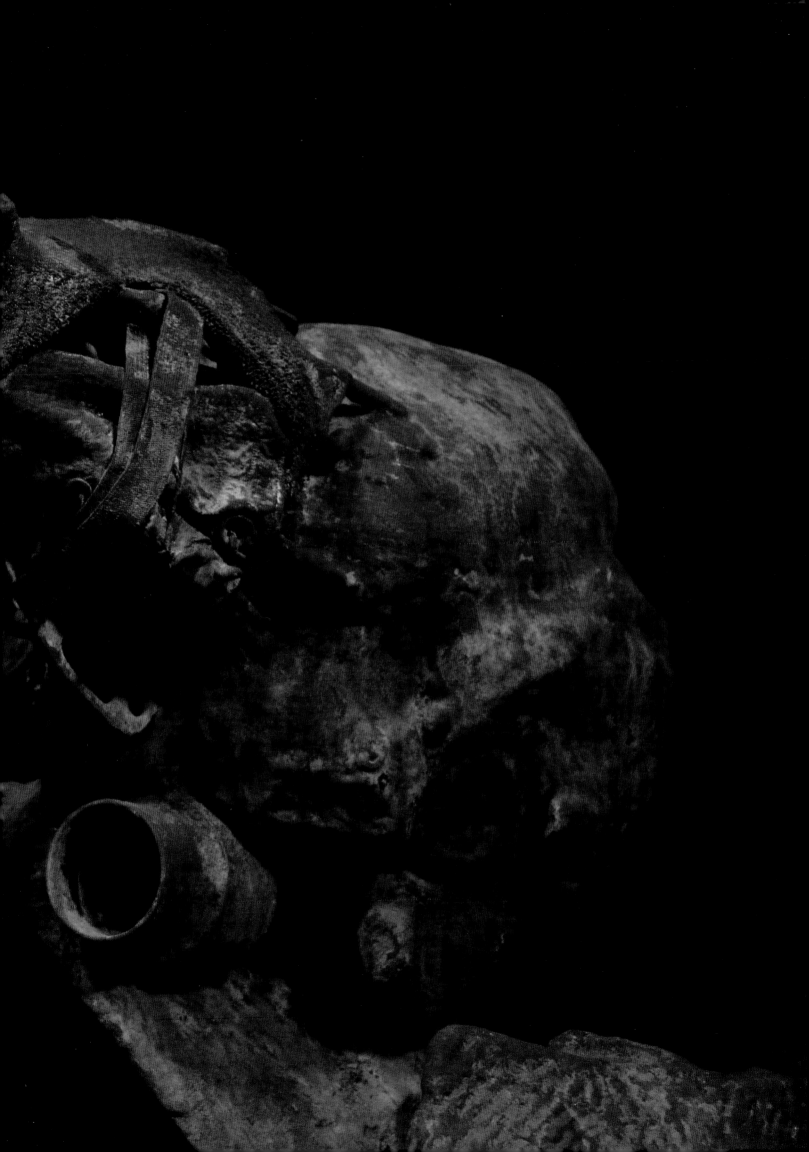

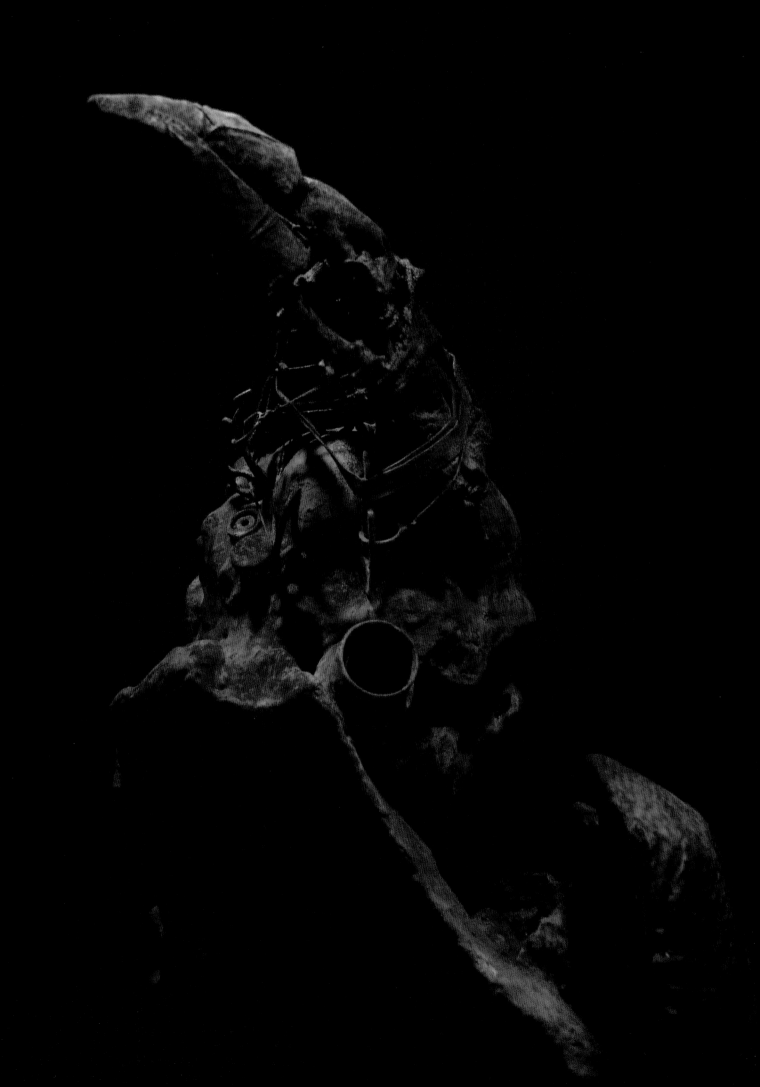

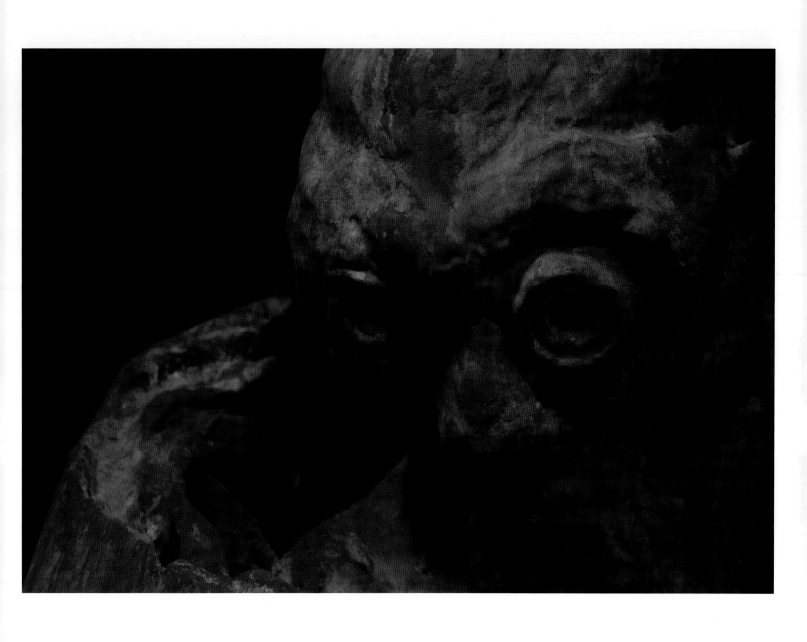

Counterweight - Rick O'Brien

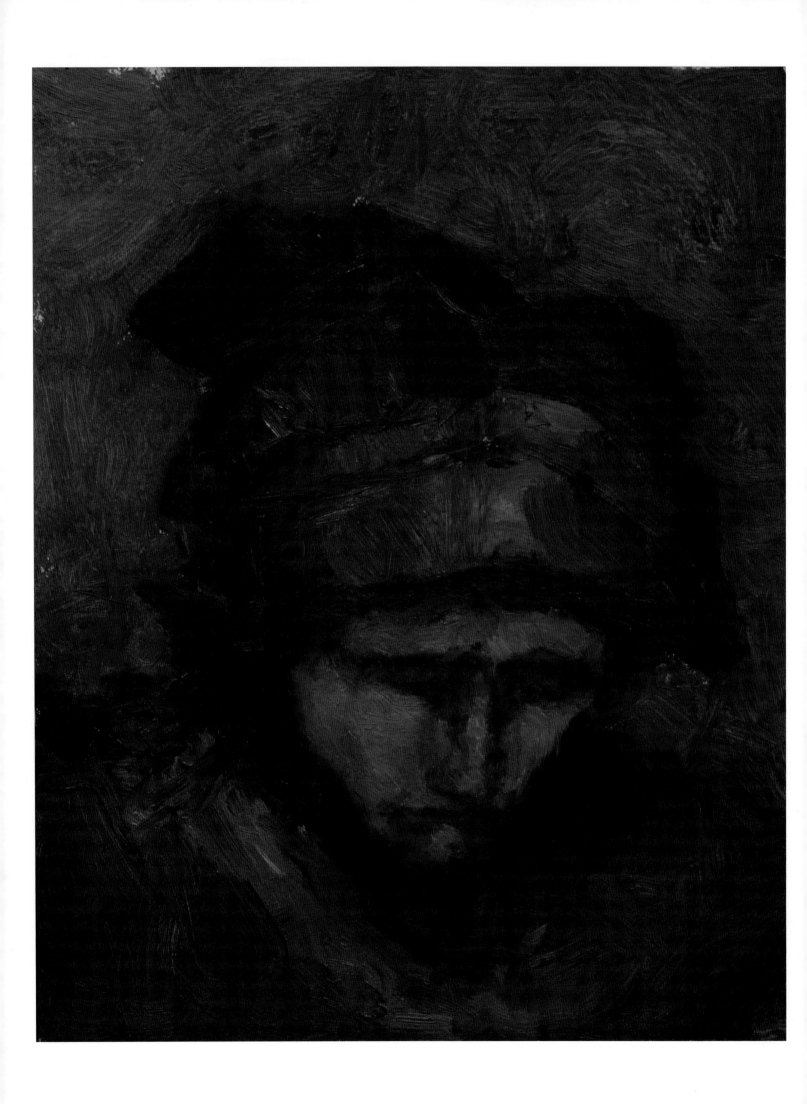

Counterweight - Rick O'Brien

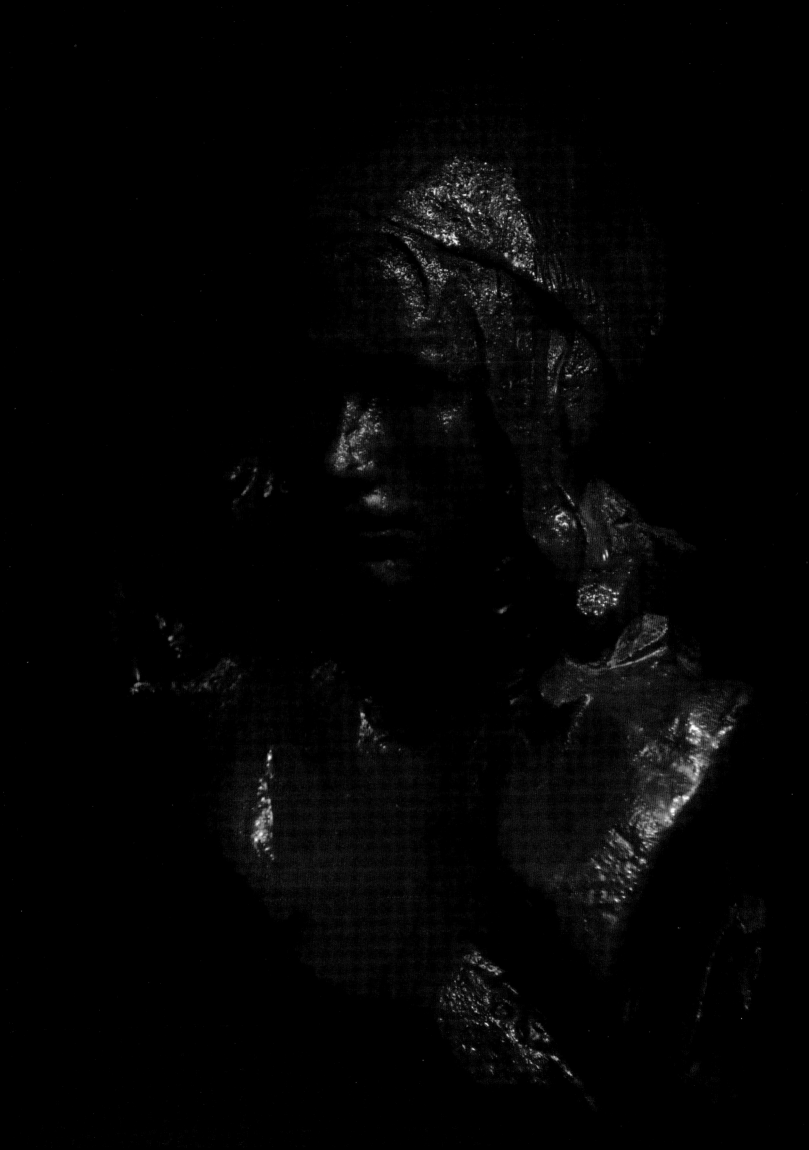

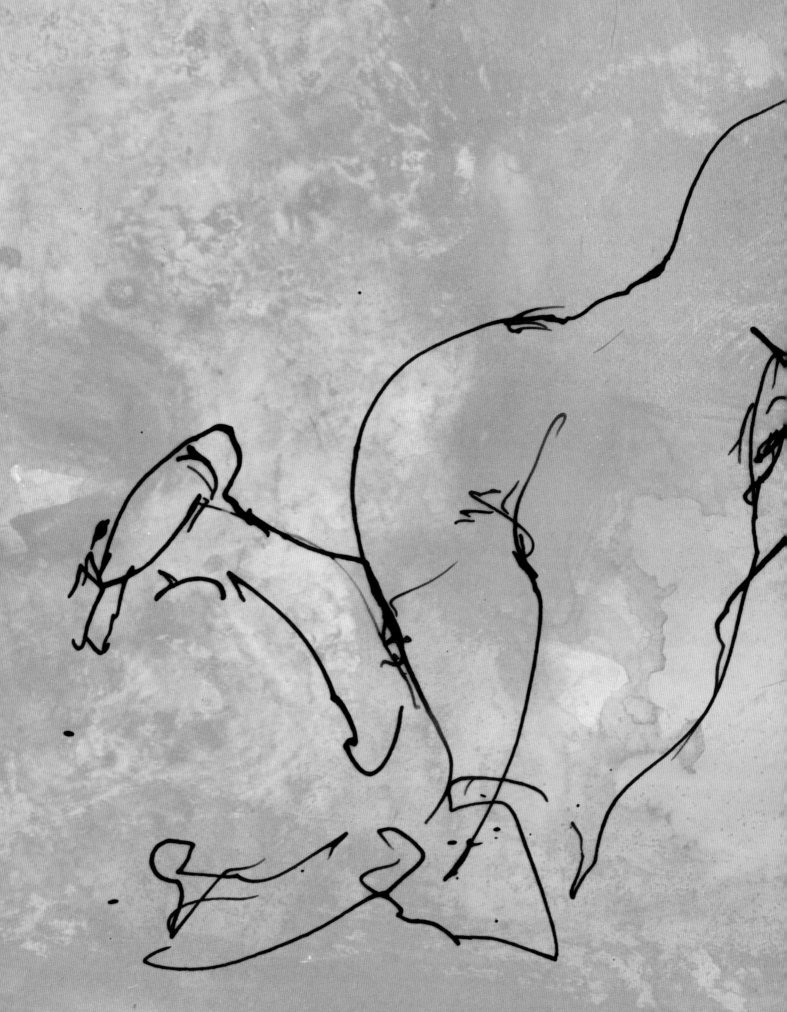

closing thoughts

As with any significant undertaking, there follows a great deal of support. The creation of *Counterweight* has been a labor close to my heart. I'm truly honored and profoundly gratified to have had the opportunity to commit my vision to these pages. Foremost, I'd like to thank Scott at Design Studio Press for his belief in my work. His efforts along with Tinti, Marsha, and the rest of the DSP publishing family, have given this artist something to be truly proud of. Thank you.

Of course it doesn't end there….

My deepest appreciation goes out to all of those who have supported and contributed to the creation of this book. First, thank you Mom and Dad, Bill, G-Ma, Linda, Terry and all of my family near and far. Special thanks to Mr. Bishop, Dave Christiana, Scott, Peter, Zack, Ray, Roxy, Pete, Fred, Jeannie, Bill Dickey, Gary Stebbings, Brandy Schull, Aurora, Elizabeth Mohr, Sharon and Ray Morelli, Andy and Mike Ketcham, Mary Jane and Ralph Lampert, Dinosaur, Oliver and everyone who has supported my work over the years. Thank you.

bio

One of two children in an Air Force family, Rick was born to William and Judy O'Brien in the summer of 1972. With brief stints in South Carolina, Taiwan, and Illinois, the family eventually settled in a small town outside Phoenix, Arizona. His first exposure to art education began his sophomore year of college, where he graduated with a BFA from the University of Arizona. Rick began his creative career with a flirtatious effort as a freelance illustrator. Not quite ready to paint for others, he found it necessary to explore issues and aesthetics closer to his heart. Pursuing fine art led Rick from the viridian lushness of the Irish countryside to the textures, rich history and cool slate palette of the Czech Republic. Searching for a new forum for his emerging artistic skills, Rick moved to Los Angeles in the spring of 1998, where he has enjoyed a steady diet of carpentry, set and property design and fabrication, scenic painting and toy making.

Rick O'Brien lives and creates with his love, Mindy, in Eagle Rock, California.

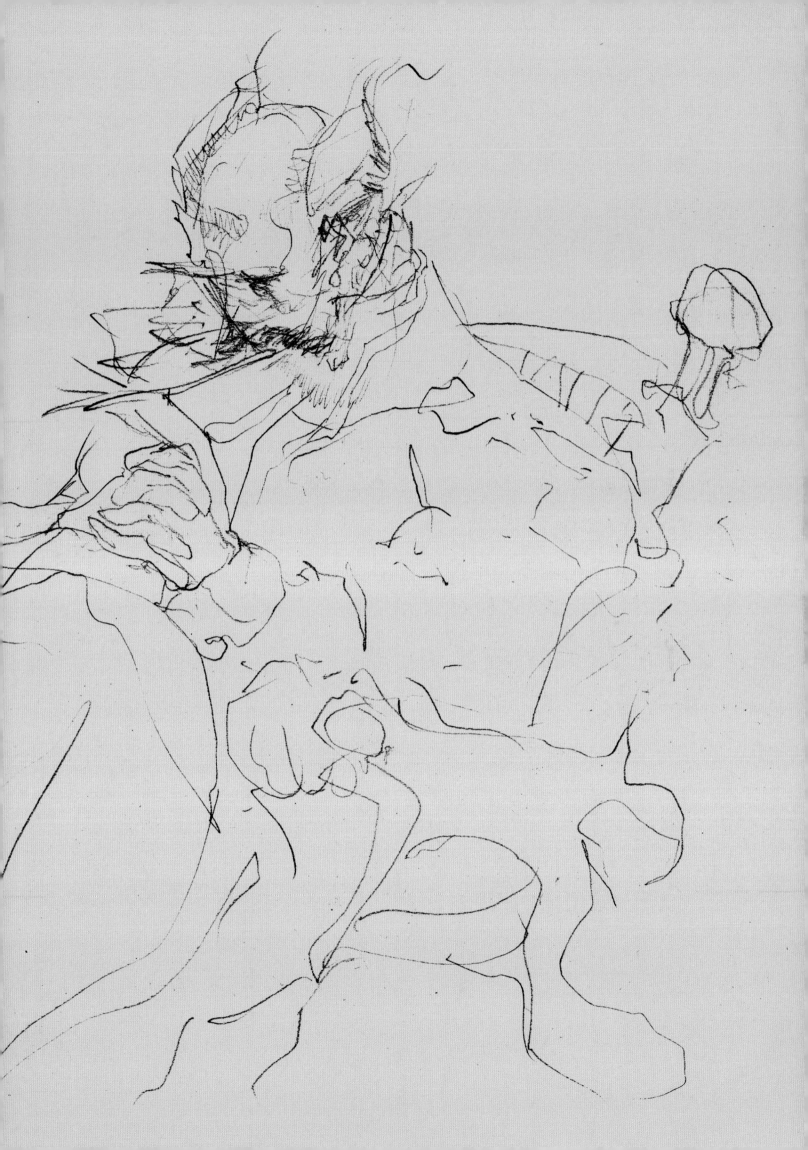

index of artwork

the paragon of animals

007. **Red Hunter**
ink on watercolor paper
11" x 14"

008. **nude study**
ink on newsprint
24" x 18"

010. **figure study**
ink on panel
8" x 10"

011. **figure study**
graphite and gouache, watercolor paper
12" x 16"

012. **nude study**
charcoal and gouache, watercolor paper
11" x 15"

015. **nude study**
ink on newsprint
24" x 18"

019. **figure study**
oil on panel
8" x 10"

020. **sitting nude**
ink and gouache, watercolor paper
11" x 15"

023. **Foundation**
mixed media
7" x 5"

perspective through geography

024. **Airship**
ink and gouache, watercolor paper
14" x 20"

027. **Docking**
ink, charcoal and gouache on paper
23" x 34"

028. **Shipwreck**
egg tempera and ink on clayboard
11" x 6"

029. **Storm**
oil on paper
7" x 5"

031. **Lighthouse**
oil on panel
16" x 20"

033. **Pub Ship**
ink and gouache on watercolor paper
12" x 16"

034. **untitled**
oil on panel
18" x 24"

037. **Chess**
ink and gouache on watercolor paper
11" x 15"

the range of humanity

040. **Blue Armor**
ink and gouache on watercolor paper
11' x 14"

043. **Gold Armor**
ink and gouache on watercolor paper
11.5" x 15"

044. **Next in Line**
pen and ink on watercolor paper
11" x 15"

045. **Blue Head**
ink and gouache on paper
11" x 14"

046. **untitled**
ink on paper
8" x 12"

047. **untitled**
ink on paper
11" x 14"

051. **The Hunter**
oil on panel
24" x 48"

053. **Blind**
oil on panel
24" x 48"

054. **Fortitude**
oil and charcoal on watercolor paper
20" x 28"

057. **Judgment**
oil on panel
24" x 48"

058. **untitled**
pen and ink on paper
11" x 14"

060. **Father's Studio**
oil on canvas
11" x 14"

061. **The Judge**
oil and ink on wood
10.5" x 18.25"

062. **Emily**
oil on paper
7" x 16"

063. **Window**
egg tempera and oil, watercolor paper
10" x 15"

064. **Father's Marker,** under painting
egg tempera on watercolor paper
20" x 14"

065. **The Inquisition**
oil on canvas
9" x 12"

Counterweight - Rick O'Brien

066. **Father's Marker**
oil on watercolor paper
20" x 14"

069. **Vanity**
oil on panel
24" x 48"

peripheral

072. **Fallen**
ink on panel
8" x 10"

074. **Kilkar**
oil on panel
36" x 24"

076. **untitled**
ink and gouache on watercolor paper
15" x 22"

079. **Adrift**
mixed media
10.25" x 13.75"

080. **untitled,** Icarus series
ink and gouache on canvas
5" x 7"

081. **Icarus**
ink and gouache on canvas
16" x 20"

082. **untitled**
ink on paper
24" x 18"

084. **The Bridge**
oil on paper
8.5" x 11"

085. **Red Towers**
ink on watercolor paper
11" x 15"

086. **Burden**
egg tempera and oil on clayboard
24" x 18"

089. **Egon's Exile**
oil on panel
48" x 24"

090. **Krumlov**
egg tempera and oil on panel
14" x 10"

093. **Door 22**
oil on paper
11" x 14"

094. **Earth Bound**
ink on clayboard
11" x 14"

095. **Mother Nature**
oil and gouache on paper
4" x 7.5"

097. **Stiltwalker**
oil on paper
8" x 12"

098. **Seated Royal**
ink and gouache
11" x 14"

099. **Hamlet's Apparition**
oil on panel
15.25" x 23.25"

100. **Musicians,** study
oil on paper
19.5" x 12.5"

102. **untitled**
ink and gouache on watercolor paper
7" x 11.5"

104. **Royal Portrait**
oil on panel
12" x 16"

106. **Forest**
oil on panel
24" x 12"

108. **St. Charles Bridge Samurai**
oil on linen
14" x 22"

109. **Bag Piper,** detail
oil on panel

relics

110. **Old Man**
mixed media
10.5" x 11" x 10.5"

114. **General**
mixed media
15" x 19.75" x 11.5"

115. **General,** study
oil on illustration board
10" x 15"

116. **Monocle**
mixed media
17.5" x 24.5" x 24"

122. **untitled portrait**
oil on panel
8" x 10"

123. **Red Bust**
mixed media
15" x 17" x 8.5"

other titles by design studio press:

ISBN 0-9726676-0-1

ISBN 1-9334920-2-3

ISBN 1-933492-27-9

ISBN 1-9334925-1-1

ISBN 1-9334921-3-9

ISBN 1-9334921-5-5

ISBN 1-9334921-7-1

ISBN 0-972-6676-4-4

ISBN 0-9726676-9-5

ISBN 0-9726676-5-2

ISBN 1-933492-01-5

ISBN 1-933492-19-8

ISBN 0-9726676-2-8

ISBN 1-933492-07-4

ISBN 1-933492-25-2

ISBN 1-933492-04-X

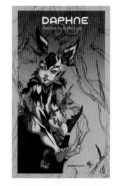

ISBN 1-9334920-9-0

To order additional copies of this book
and to view other books we offer, please visit:
www.designstudiopress.com

For volume purchases and resale inquiries,
please e-mail:
info@designstudiopress.com

To view a selection of our educational DVDs,
please visit:
www.thegnomonworkshop.com

Or you can write to:

Design Studio Press
8577 Higuera Street
Culver City, CA 90232

tel 310.836.3116
fax 310.836.1136